The 15-Minute Artist
101 DRAWING SECRETS

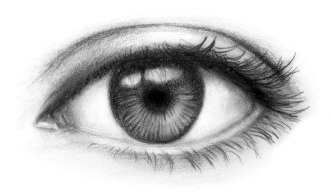

The 15-Minute Artist
101 DRAWING SECRETS

Take Your Art to the Next Level with Simple Tips and Techniques

Catherine V. Holmes

Get Creative 6
An imprint of Mixed Media Resources
104 West 27th Street
New York, NY 10001

Senior Editor
MICHELLE BREDESON

Art Director
IRENE LEDWITH

Chief Executive Officer
CAROLINE KILMER

President
ART JOINNIDES

Chairman
JAY STEIN

*To my best girls,
Charlotte and Taya Cate*

Library of Congress Cataloging-in-Publication Data

Names: Holmes, Catherine V., author.
Title: 101 drawing secrets : take your art to the next level with simple
 tips and techniques / by Catherine Holmes.
Other titles: One hundred and one drawing secrets
Description: First edition. | New York, New York : Get Creative 6,
[2021] |
 Includes index.
Identifiers: LCCN 2020050465 | ISBN 9781684620180 (paperback)
Subjects: LCSH: Drawing--Technique.
Classification: LCC NC730 .H5595 2021 | DDC 741.2--dc23
LC record available at https://lccn.loc.gov/2020050465

Manufactured in China

1 3 5 7 9 10 8 6 4 2

First Edition

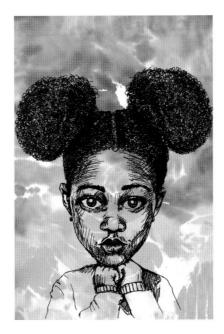
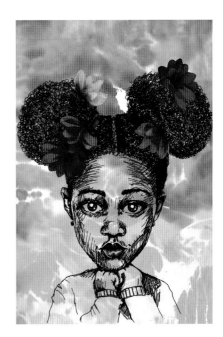

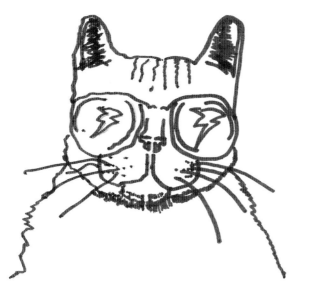

Acknowledgments

Thank you to all of the friends who modeled for or helped inspire some of the images in this book: David Thayer, Virginia Thayer, Dexter Newgen, Kenneth Holmes, Taya Cate, Charlotte Virginia, Jay Costello, Mike Willwerth, my nana and papa's friends, and little bits and pieces of my students (former and current) used to create some of the fictional characters within.

I want to thank SoHo Publishing for making my dreams come true by spotlighting *The 15-Minute Artist* in my favorite store. What a thrill it is to see my book on the shelves as I shop for art supplies! A big thank-you to Usher Morgan for supporting my work and making it accessible across the world. Thank you to my Multiples Mafia Moms, my students and colleagues, the Holmeses, McRaes, Gouldrups, Balentines, Goslins, Thayers, Duseaults, and the rest of my family for supporting my choice to be an artist in an uncertain world. I am blessed beyond words to have you in my life to carry on traditions and to help make things seem normal.

Contents

Trees
and
stones
will
teach
you

what
you can
never
learn
from
masters

St. Bernard

Grow Your Drawing Skills...One Secret at a Time!

Drawing is a skill. Drawing is a learned technique. Drawing is not a magical ability that some people are born with. It is something anyone can learn. If you want to learn how to draw, you can.

I have been drawing, painting, and teaching art to people of all ages for many years. I have logged countless hours of drawing practice. In learning to draw and improve my artwork, I have figured out many tips, secrets, hacks, and shortcuts to better and easier drawing. In this book, I will share them with you to help save you some time on your journey to becoming a better artist.

The tips I share here cover many areas of drawing and art. Each secret is meant to stand on its own, but they are organized into chapters of related tips so you can explore an area of drawing and art in more depth if you care to. You will learn ways to draw more accurately, add depth and realism to your drawings, draw convincing people, and be a more confident and creative artist.

There are a number of ways to approach the tips in this book. Start at the beginning, read the text, and try out the tips as you learn them. Or, turn to a section that interests you and dive in. Flip to tips at random and pick up bits of knowledge, inspiration, and guidance you can use right away. There's no wrong way to use it.

My last book, *The 15-Minute Artist*, is a collection of step-by-step tutorials you can complete in about 15 minutes. The secrets in this book can also be read and implemented in just a few minutes. There are many that touch on vast topics such as perspective, shading, and figure drawing. You will be able to incorporate them into your drawings right away, but you can then spend a lifetime exploring and practicing them. It's up to you.

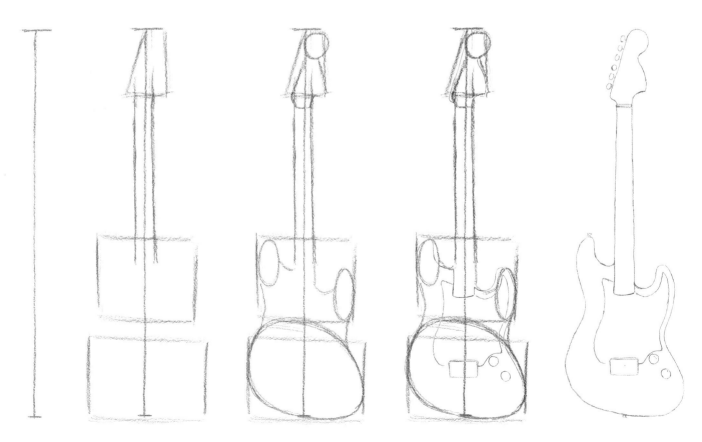

Before You Start

Here are a few thoughts to get you in the right state of mind to learn from the tips and hints in this book and to succeed in all your artistic endeavors.

- Remember that anyone can draw, but no one can draw just like you.

- Use your imagination and have fun. You are the creator, and anything is possible.

- Draw from observation as much as possible (although drawing from photos is also good practice and can be easier because they're already flattened to two dimensions).

- Don't compare your skills to others. You have your own special style (whether you know it or not) that is unique to you.

- Make your art for you, not what you think others want to see. If you make art for yourself, you will be invested and have more fun!

- Take baby steps and remember that any progress is progress.

- The real secret to improving your drawing skills is that there is no secret. It just takes practice. Practice seeing and practice drawing.

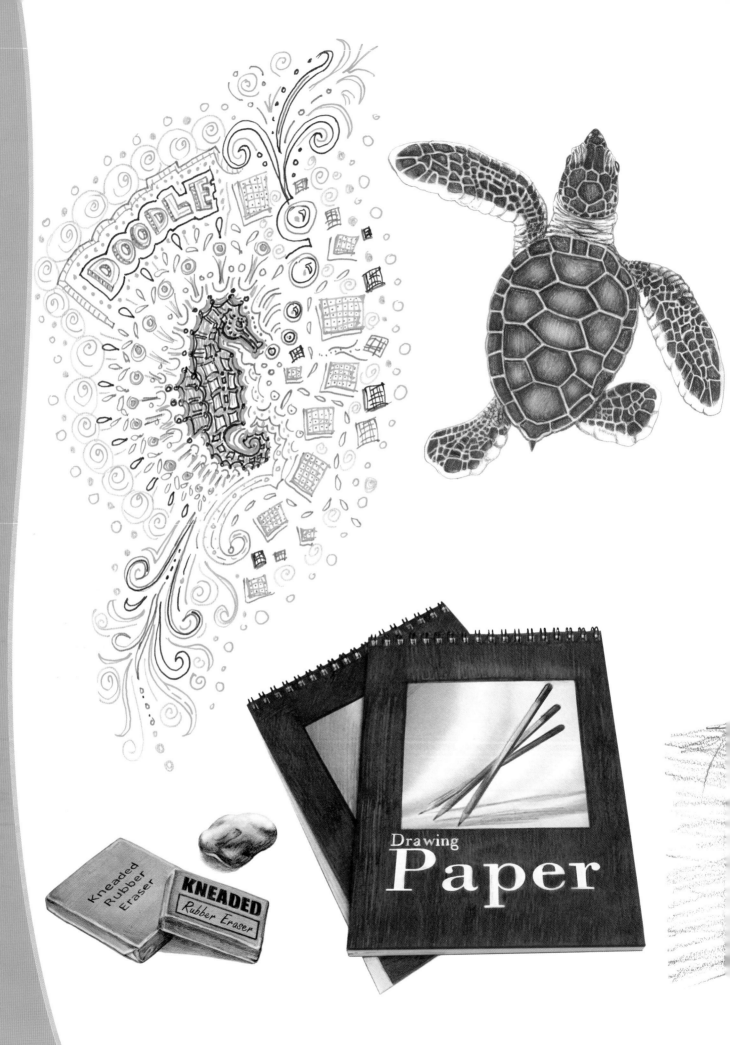

Start Drawing!

Even if you don't read this book cover to cover, I recommend starting with this chapter. The tips shared here will help you choose the right drawing tools to use, warm up your hands and brain, get acquainted with the basic elements and principles of art, and develop an effective drawing practice. Once you have these basics down, you'll be set to draw anything!

1 Choose the Right Pencil

While you can use any pencil to draw, artist pencils create more dynamic marks than common writing pencils, so I recommend you try a few.

Artist pencils usually have a number and a letter embossed or painted on the end that indicate the hardness of the core graphite and the degree of hardness.

If a pencil has an "H" on it, it's a hard pencil. H pencils make light, sketchy lines that are useful for drawing and sketching. The number in front of the H, ranging from 2 to 9, indicates how light the mark will be. The higher the number, the harder the writing core, and the lighter the mark.

If a pencil has a "B" on it, it's a soft pencil. B pencils make dark, smudgy lines that are useful for shading. The number in front of the B, ranging from 2 to 9, indicates how dark the mark will be. The higher the number, the softer the writing core, and the darker the mark. (F and HB pencils are in the middle of the hardness scale.)

The best pencils to start with are 2H–4H for light sketching and 4B–8B for adding tone and shade.

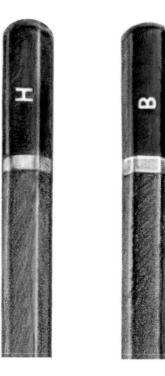

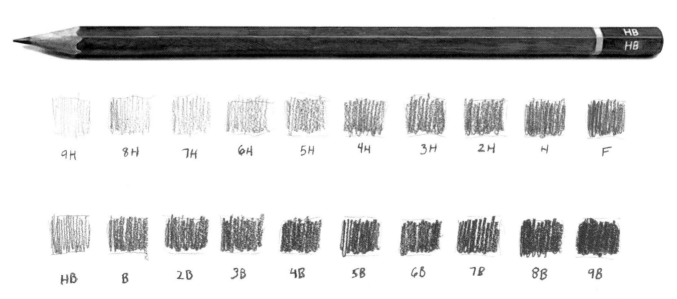

As you can see, the scale goes up to 9 at each end, 9H being the hardest and lightest mark maker to 9B being the softest and darkest mark maker. Both of these extreme ends of the scale are often too light or too dark for regular use.

2 Know Your Pencil Grips

There are many ways to hold a pencil that will allow you to make different marks, but ultimately you should choose a grip that is comfortable and successful for you. Here are a few to try:

Tripod Grip

This grip allows you to hold the pencil with the most control and accuracy. It is best for working on small, detailed areas when you wish to limit stroke length. However, this grip is tight and doesn't allow for long strokes, and your wrist is usually anchored to the paper, so it's easy to smudge your work.

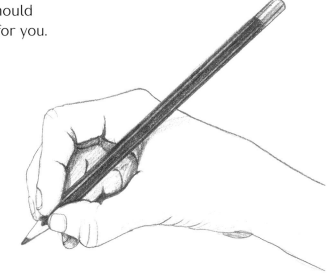

Basic Drawing Grip

Hold the pencil with your index finger and thumb higher up on the pencil than the tripod grip, closer to its center. You will be able to make larger movements and longer lines since your wrist is not anchored to the paper, which limits movement, and your whole arm (not just your fingers) is enabled. This technique is not meant for detailed marks, but you can still maintain control when needed.

Overhand Grip

Holding the pencil lightly with the flat of the thumb on the bottom with a secure but relaxed grip on the pencil should give you a full range of movement, allowing for free, expressive mark-making. This grip is great for sketching. It allows you to make marks with the side of the pencil while promoting loose lines.

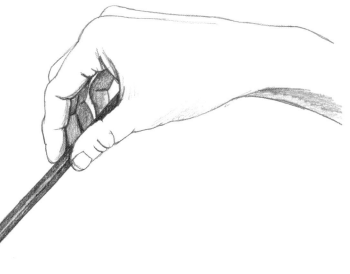

③ Pick the Right Paper

Paper is an important but often overlooked drawing tool. It is the literal foundation of your artwork. The choices of drawing paper are truly endless, and each type will create a different look.

While it may be tempting to grab a piece of cheap printer paper or other non-drawing paper, that would be a mistake. The wrong type of paper can make your artwork appear flat and uninteresting, especially when shading in large areas of the same tone. Cheaper paper also makes it difficult to blend shades into one another. Copy paper can be used for quick studies or exercises, but choose dedicated drawing paper for your finished artwork.

Be sure to choose paper that has the right surface quality (tooth or roughness) for the medium (type of drawing tool) you'll be using. The label will usually specify the recommended medium.

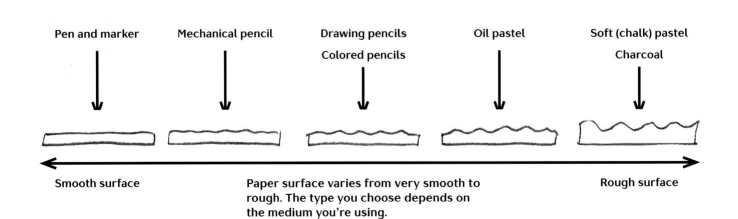

| Pen and marker | Mechanical pencil | Drawing pencils | Oil pastel | Soft (chalk) pastel |
| Colored pencils | | Charcoal |

Smooth surface Paper surface varies from very smooth to rough. The type you choose depends on the medium you're using. Rough surface

4 Make Your Mark

There are an infinite number of marks that are possible in drawing. Each artist will make a unique set of marks, and those marks are often part of their signature style (see Secret #83).

Experiment with a pen or pencil to see how many different marks you can make. Practicing making different marks with your chosen tool can help you express feelings and emotions on paper, turning exciting, energetic marks into an expressive drawing.

Quick Tip

Trying out different mark-making techniques is also a great way to become comfortable with your chosen tool and exercise your imagination.

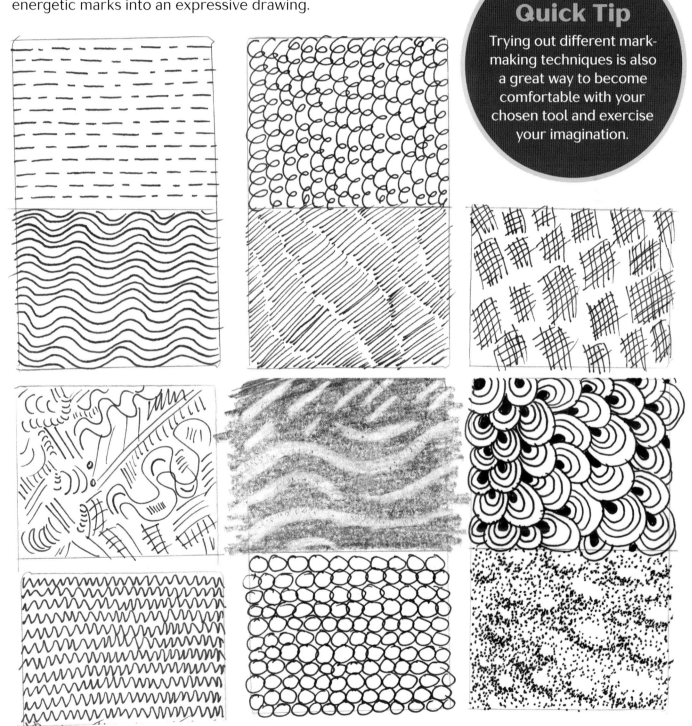

5 Try a Kneaded Eraser

A kneaded eraser is a staple of any artist's toolbox. Unlike rubber erasers, kneaded erasers don't shed bits of residue. Even more importantly, they can be molded by hand to any shape needed, allowing you to make a variety of marks. Use them for meticulous erasing, removing pigment to create highlights, or performing detailed work.

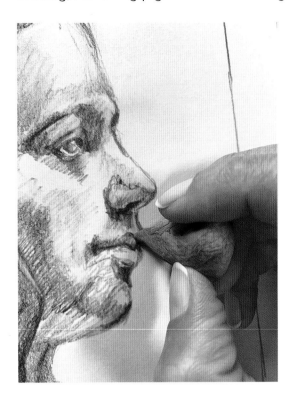

It's easy to shape a kneaded eraser to erase any size area.

Tips for Using Kneaded Erasers

- Break in the eraser by stretching and kneading it. The more you use it, the softer and more malleable it will be.
- Dab at an area to help remove tone rather then dragging the eraser across the page.
- If you need to completely remove graphite, use a vinyl or rubber block eraser instead.
- For smudges and fingerprints, hold the paper with one hand, while gently wiping the eraser across the page with the other.
- To remove tone from small areas, sculpt the eraser into a point by rolling it between your fingers. Press the point of the eraser onto the area in need of pigment removal a few times until the desired result is achieved.

- Kneaded erasers become dirty with use. To clean, knead it until the color turns light gray.
- Store it in a closed container to lengthen its life span.

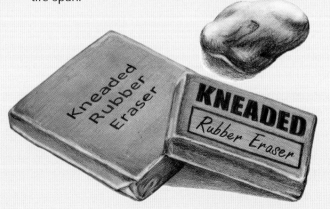

6 Beware of the Smudge

Have you ever been working hard on a drawing only to find that it's become smeared? When drawing, it's important to smudge and blend only when you intend to! Luckily, it is simple to avoid unintentional smearing. If you tend to rest the heel of your palm on your paper, try taping paper to your palm or laying down a piece of tracing paper as a barrier. You can also use a mahlstick, or hand rest, to steady your hand and keep it raised from the surface. The type of pencil you use also makes a difference. Remember that the softer the graphite (anything in the high B range) will smear more easily. Also, don't brush eraser crumbs off with your hand! This can ruin your hard work with one swipe. Use a soft paintbrush or simply blow the bits away.

7 Use Fixative

Despite all the precautions you take, smudging can still happen. A fixative is an aerosol liquid that is sprayed onto dry media, such as graphite, charcoal, and pastel, to protect it from smudging, yellowing, and dust. It comes in a matte or glossy finish. If you use a workable fixative, you can add more dry media on top of it and even erase some of marks. Use a non-workable fixative for a final layer of protection. To apply fixative, find a well-ventilated location and do a test spritz. Make sure it doesn't change the color of the pigment or paper in an undesirable way. Hold the nozzle at least one foot from your drawing and sweep across the surface with smooth strokes. Several light spritzes are better than one long, wet blast. Add a second coat when dry if needed.

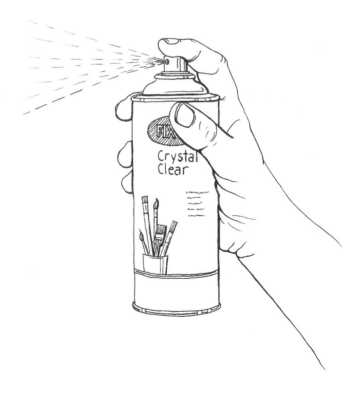

8 Employ the Elements of Art

Line, color, shape, form, value, space, and texture are the seven core elements of art. All artworks, from two-dimensional paintings to three-dimensional sculptures, include one or more of these elements. Understanding these visual elements can aid in both creating and appreciating a work of art.

Line

Line is the foundation of drawing. There are many different types of lines, including horizontal, vertical, wavy, diagonal, and more. Lines can be straight or curved, implied or actual. Use line to create shape and form, as well as to give a sense of depth and structure.

Color

Color is present when light strikes an object and it is reflected back into the eye, a reaction to a hue arising in the optic nerve. Your choice of colors will have a big impact on composition and the mood of your artwork.

Shape

Shapes are areas of enclosed space that are two-dimensional. Shapes are flat and represent only length and width. The two different categories of shapes are geometric and organic. Combining a variety of shapes of both kinds adds interest to your drawings.

Form

Forms have length, width, and depth. Balls, cylinders, boxes, and pyramids are forms. Use form to produce an illusion of three dimensions and depth on a two-dimensional surface.

Value

Value refers to the lightness and darkness of color or tone in an artwork. It is created when a light source shines upon an object, forming highlights, shadows, and midtones. Use a full range of value to create contrast and add emphasis while offering the illusion of depth.

Space

Space refers to the distances or areas around, between, and within components of an artwork. The space can be positive or negative, open or closed, shallow or deep, and two-dimensional or three-dimensional. Create space by overlapping objects, placing objects on different planes, changng the size of objects, or using perspective.

Texture

Texture is the surface quality in a work of art that can be seen or felt. Textures can be rough or smooth, soft or hard. While sculpture and even paintings can have actual textures, drawings need to use implied textures. This can be done through the use of different marks and a range of values.

TEXTURE

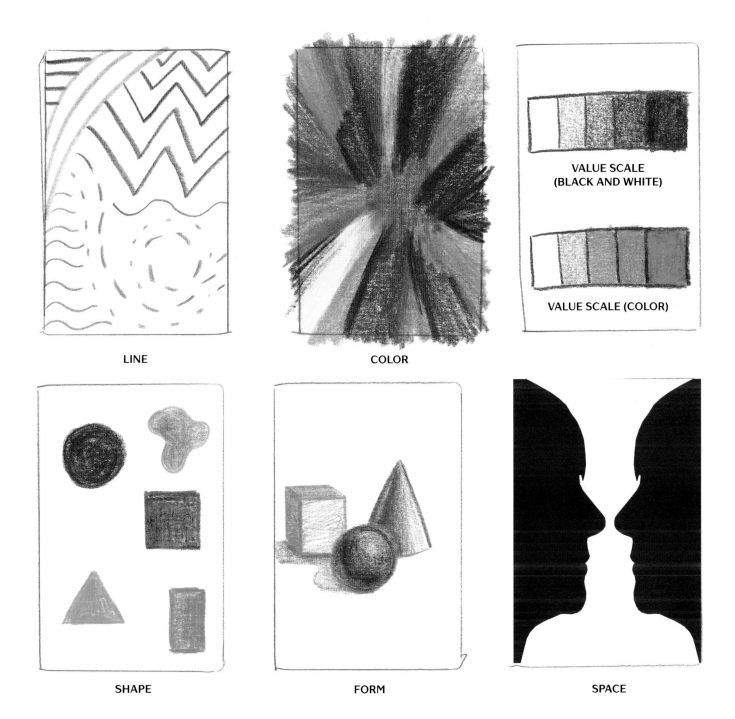

LINE

COLOR

VALUE SCALE
(BLACK AND WHITE)

VALUE SCALE (COLOR)

SHAPE

FORM

SPACE

⑨ Warm Up with Doodling

A doodle is a simple drawing composed of spontaneous, uncensored marks. Doodles can take many forms, from abstract patterns or designs to images of concrete objects. Doodling often has a bad connotation, but these marks are far from being the senseless scribbles of a distracted mind. Doodling is an exercise that can help you focus, gather ideas, warm up your hands and mind, or simply relax. It also provides a nonverbal outlet for entertainment, relaxation, problem-solving skills, building confidence, and improving hand-eye coordination—to name just a few.

Tips for Doodling

- There doesn't need to be a right side up. Any way the paper is held, the design should look good.
- Don't plan. The results should be a surprise.
- Avoid drawing recognizable pictures that can inhibit the simplistic nature of the exercise.
- Start small. This will enable you to add a lot of detail without feeling overwhelmed.
- Use all the space at your disposal, but don't cram in content; negative, or empty, space can be an important part of the layout.
- Certain areas should have more "weight" or thicker lines and shapes to create interest.
- Doodles with an equal balance of dark and light shapes/designs are the most pleasing to the eye.
- Don't erase. Let your doodle evolve without a plan.
- Try to combine at least five different patterns.

10 Sketch Daily

Want to improve your artwork? Draw a little bit every day! Setting aside time to draw each day will boost your artistic skills, help you critique your own work, and allow you to focus on areas that may need improvement. It doesn't have to be part of a routine or a scheduled time; you may pick up your sketchbook during a lunch break, while waiting for the morning coffee to brew, or while watching your kids at the park. Or you may do better with more structure and a specific time and place each day. Whether it's a few minutes or a few hours, any amount of time can be beneficial. Try to focus your drawing efforts toward sharpening certain skills. When you draw every day, there's no burden to make every drawing a masterpiece. Just get sketching daily so you can start making progress.

11 Observe

When drawing from life or an image, you should be looking at that reference at least 50 percent of the time. To produce a believable observational drawing, your eyes must continually move from the object to the drawing and back again. Looking at the subject frequently will help curb habitual ways of seeing and develop a new awareness. In other words, observation helps you draw what an object actually looks like, not how you *think* it should look. The only way to record tone, shadows, changing light conditions, various textures, proportions, and detail accurately is to look at the source of information. You may try to do this from memory; however, a memory cannot hold the same amount of information as observation.

12 Follow an Art Tutorial

Art tutorials are everywhere. From books to online demonstrations to small classes, they coach by example and supply specific information to complete a certain task.

There are many advantages to online tutorials. You're able to learn whenever and wherever is most convenient for you. You can stop and start the tutorial as often as you need to for breaks or to repeat sections for clarification. And by completing a tutorial, you can get a sense of accomplishment and a boost in confidence.

There can be disadvantages as well. It is not always possible to ask questions, the tutorial might have too little or too much information for your skill level, and you also won't have the motivation of other students.

Here's an example of the kind of step-by-step tutorial you might find in a book or other format.

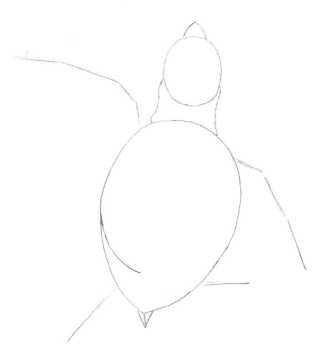

1 Sketch out the basic shapes for the turtle's head and body/shell. Add lines to indicate the legs and neck.

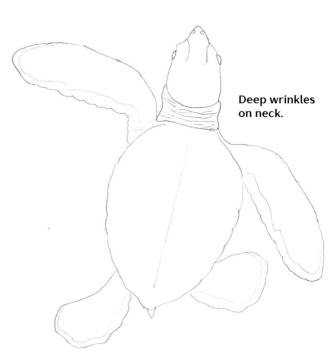

Deep wrinkles on neck.

2 Thicken the legs and add the eyes, nostrils, and details of the neck.

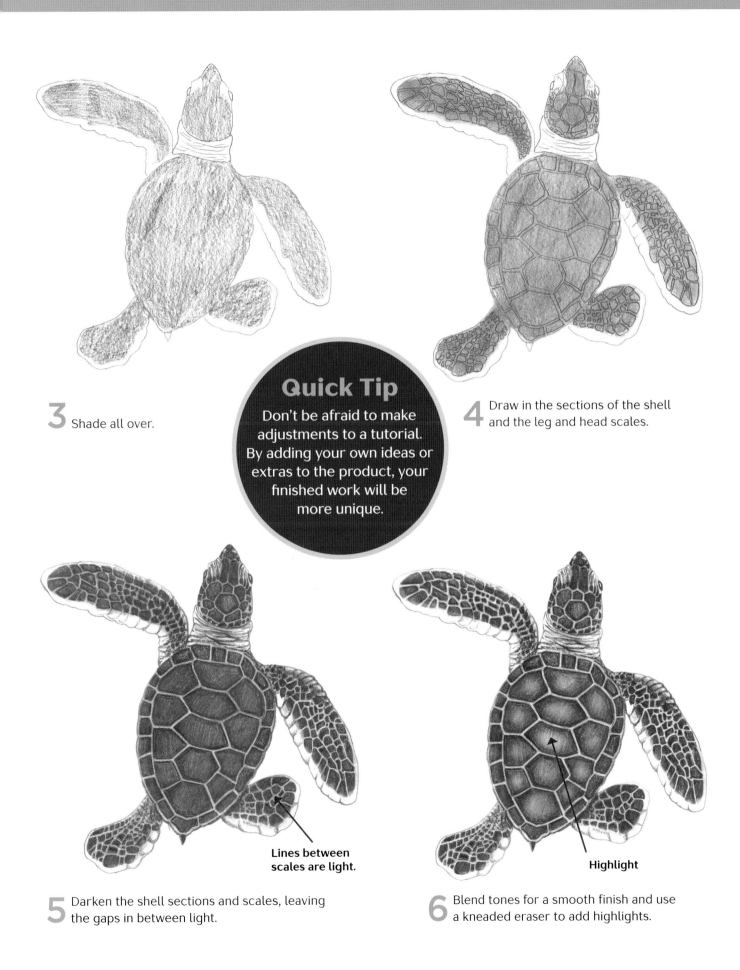

3 Shade all over.

Quick Tip
Don't be afraid to make adjustments to a tutorial. By adding your own ideas or extras to the product, your finished work will be more unique.

4 Draw in the sections of the shell and the leg and head scales.

Lines between scales are light.

5 Darken the shell sections and scales, leaving the gaps in between light.

Highlight

6 Blend tones for a smooth finish and use a kneaded eraser to add highlights.

13 Try Blind Contour Drawing

Blind contour drawing is a favorite technique of drawing teachers to help students improve their observational skills. While a contour drawing is an outline of an object, blind contour drawing simply means drawing an object while not looking at it. Blind contour drawing requires focus and observation toward the subject you're drawing, This helps improve visual concentration while training your eye and hand to work together to see all of the details of the object. To do a blind contour drawing, put the point of a pencil to paper and look at a specific point on your subject. Once your pencil and line of vision are aligned, follow the contours of the object. As the eye moves from one detail to another, so should the hand holding the pencil. The eye and hand should be in sync.

Quick Tip
Use a drawing pad with a cover and leave the cover over your hand as you draw so you won't be tempted to sneak a peek.

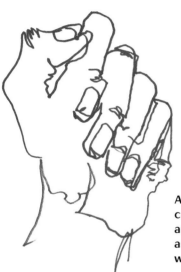

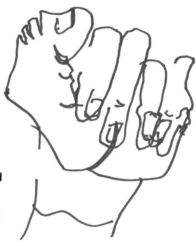

A popular subject for blind contour drawing is to look at your non-drawing hand, as it has lots of curves and wrinkles.

Blind contour drawings may not be frame-worthy, but they will greatly improve your drawing skills.

 Draw with Your Whole Arm

Drawing with your whole arm instead of just your wrist and hand opens up the opportunity for a deeper range of motion. To create big, flowing lines, you want to use your whole arm and bring the shoulder into it. Drawing on small surfaces tends to encourage making small movements using just the wrist or fingers. This creates a pivot that changes your line and limits the range of motion. When you reach that limit, you will have to move your hand and then start the line again. This causes you to use many lines just to achieve one line. Draw larger and fill the whole page to practice this method. Having the drawing paper in front of you at arm's length is essential. Lean a board against a table or stand behind an easel to get a better range of motion.

15 Don't Get Too Technical

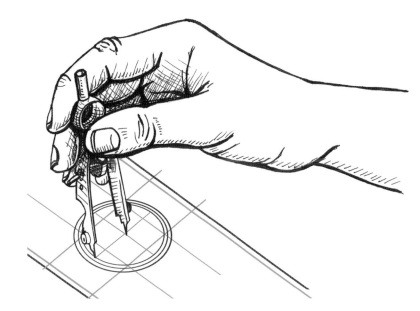

Sometimes it's necessary to create a precise and detailed drawing of an object, such as in architecture or engineering. For these fields, compasses, rulers, and protractors are necessary. While a ruler can be a great tool for getting proportions correct or making straight lines, we often don't need a straight line when we think we do. For example, my students often request a ruler to draw trees. Trees are rarely perfectly straight enough to warrant the use of a ruler. It also may be tempting to measure exactly where the rule of thirds (see Secret #36) sections should fall in order to place your design elements. Drawing freehand allows your brain and hand to perceive better through a natural process of observing and replicating without tools.

16 Go Large

The size of an artwork is an artistic decision you as the creator have to
make. While it can be a matter of space or materials available, it is more
importantly a question of effect and impact. Remember that art is much
more than just wall filler, and you, the artist, get to make the decisions based
on your desired outcome. Drawing on a large or oversized surface offers
you the experience to draw in a different way and create an impact. Working
at a larger scale promotes a loose style and the desire to create a grand
work of art. Filling a large page and adding detail is easier when you draw
larger. Big art is also more engaging for the viewer, as the extensive size
exhibits prominence and power.

Tips for Working Large

- Decide whether the
 large work will be the
 same scale as usual
 (meaning the subject
 size won't change but
 there will be more
 visuals going on around
 the main subject) or
 a much larger scale
 (meaning there will be
 much more detail in the
 work).
- Drawing on a larger
 canvas requires
 working with larger
 tools. These tools will
 help cover the surface
 swiftly, but more
 importantly, they will
 help you relax
 your style so it is not
 as tight.

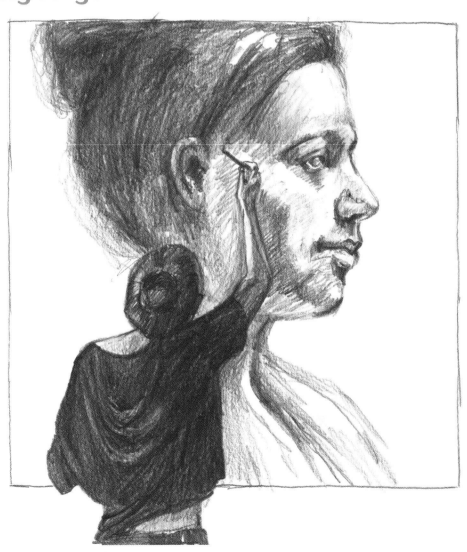

17 Turn Your Work

A simple but sometimes not obvious trick to make drawing more accessible is to turn your work! Turning your paper as you're drawing can make it easier to reach part of your drawing or just be more comfortable. As you sit and work on a piece, you may get stuck holding your sketchbook or canvas in one position. Turning your paper can make it easier to draw that tricky angle or awkward line. Turning your work is also a good option if you're trying to avoid smudging your work. It's not good practice to lean on your work, but sometimes it is unavoidable. If you turn the paper to lean on a part that hasn't been worked on yet, smudges are less likely to occur.

18 Use References

The more information we have about an object, the more accurate our drawings will be. Books and the Internet are rich with excellent photos that can used to observe and draw an object, but there are things all around us that can also be used as references: a pet, family members, trinkets on a shelf, fruit in a bowl on your counter. Just look out the window and you will find plenty of real-life objects to draw. Even when drawing from imagination, it helps to have a real image to use as a reference. In order to make a fantasy drawing look more real, for example, proportions, shadows, and highlights need to be believable.

Quick Tip

It's okay to use another person's photographs as references for personal use, but if you're going to sell or show your artwork, you should avoid it.

19 Preserve Your Whites

If you know you're going to have white or very light areas or highlights in your artwork, it's a good idea to protect those areas. First decide where the white or light areas will be. Try to avoid drawing or painting over them if you can. If you're working in pencil, you can usually erase, unless you have a very heavy hand. But even so, erased areas never seem to appear as white as the original paper. You can also cover them with painter's tape. For watercolor, apply a product called masking fluid to the areas that will remain white. When you peel it off after the paint has dried, the white paper will appear untouched.

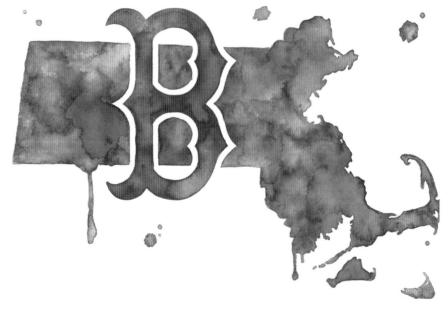

I drew the edges of my home state of Massachusetts with masking fluid before painting with watercolor to keep the details crisp.

20 Stand Up

Many artists are able to create while sitting. Others prefer to stand. There are benefits to both, depending on the size, scale, and medium of the work. Standing while drawing or painting allows for a greater range of motion—broad gestural strokes from the shoulder joints and arms, not just the wrist. Standing can improve your ability to reach different areas of the surface. Standing also allows you to easily take a step back away from the painting to get a more comprehensive view of the work to make sure all elements are working together. Viewers normally look at paintings from across a room, not super close up; therefore, you need to step back as you create the work so it reads well for the viewer.

Quick Tip

Sitting may be the best position if you're working on a small piece that doesn't require lots of free arm movements.

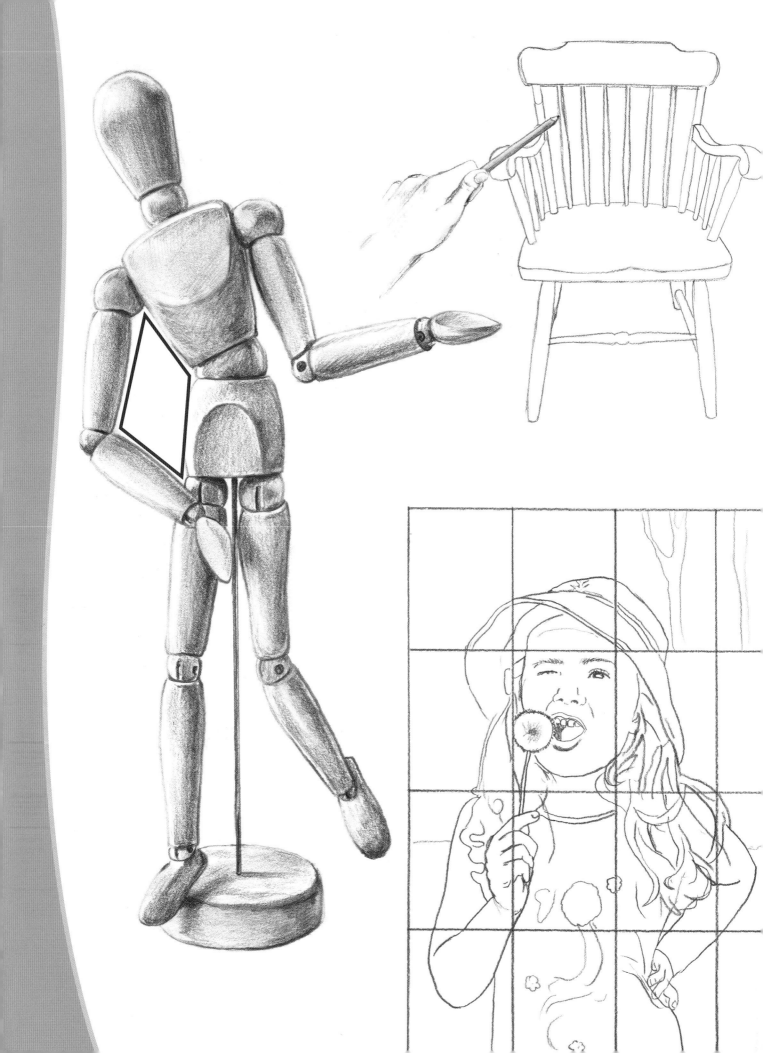

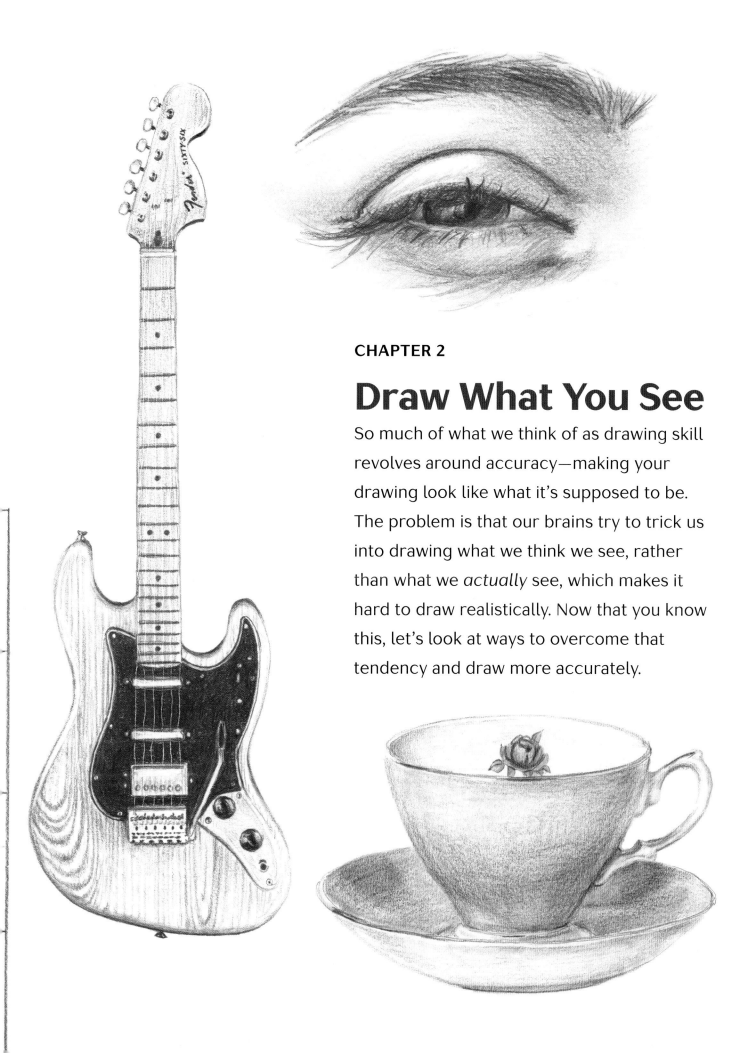

CHAPTER 2

Draw What You See

So much of what we think of as drawing skill revolves around accuracy—making your drawing look like what it's supposed to be. The problem is that our brains try to trick us into drawing what we think we see, rather than what we *actually* see, which makes it hard to draw realistically. Now that you know this, let's look at ways to overcome that tendency and draw more accurately.

21 Break It Down

When first drawing an object, you may think it is too complex to attempt. One mistake artists make is to try to see the object as a whole and replicate it that way. Upon closer inspection, most subjects have many small parts, or shapes, that are combined together to create a more complex one. The first thing an artist needs to learn is to recognize these shapes. While drawing, ask yourself questions like, "Is the largest shape a circle or an oval?" "Is this line perpendicular to the other or do they taper toward one another?" "Are these lines perfectly straight or do they fan outward?"

Here are the basic steps:

1. Start by loosely sketching the largest shapes seen within the object.

2. Continue placing shapes from largest to smallest, checking sizes as they relate to one another.

3. Once the general sketch is complete and all the major shapes have been decided, start refining the shapes, changing them or connecting them to look more like the subject.

4. Add details, tone, shadows, and highlights to complete the drawing.

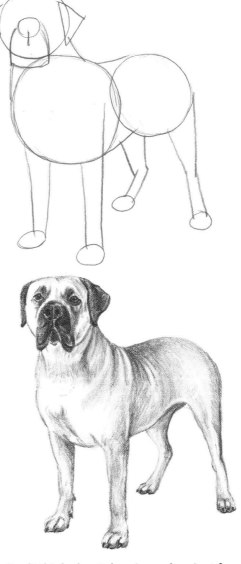

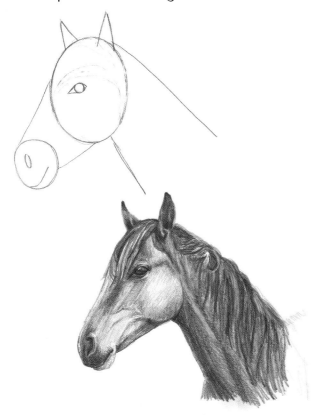

When preparing to draw, forget what the actual object is and focus on the shapes that are seen. Instead of seeing a horse's head, look at the curves, sharp edges, areas that are long and narrow, etc.

Don't think about drawing a dog, just focus on recreating the shapes you see. In this drawing, the largest shape is the chest; the second largest is the rear.

22 Compare Shapes

One way to break down complex subjects into simple forms is to start with the main shape, and then use that shape as a guideline to compare all other parts of the drawing. In order to do this, some form of measurement is needed. First, decide on an initial size for the largest part of the work. This will be the base to which all other parts will be compared. Using the naked eye, a ruler, pencil, or other tool, measure that object, then measure the relative size of the other objects and transfer your measurements to your paper. Draw what you see, ensuring that the entire subject fits on the paper and always checking and comparing parts to one another to keep them in proportion.

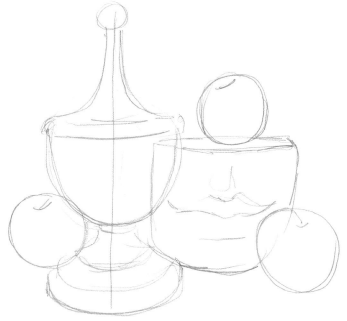

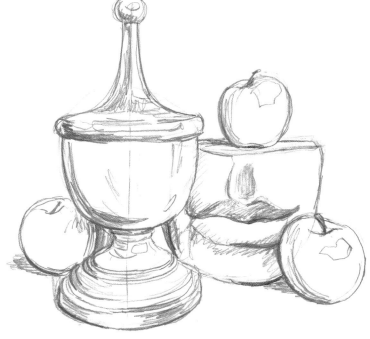

Quick Tip

It's helpful to have your subject and your drawing side by side. This will allow you to see both items in one glance and help with consistent comparison between the subject and the drawing.

To draw this still life, I measured the relative size of the tall vessel and used it as a guide to measure and draw the rest of the objects. The sculpture is about half the height, and each apple is about one quarter.

23 Change Your Point of View

As much as you are aiming for realism, your brain may keep trying to get you to draw what you *think* instead of what is actually right in front of you. You may take a quick glimpse of an object and make up the rest without investigating the actual object further. One way to force your brain to think outside the box is to study one object from multiple angles.

Choose a simple object such as a mug or a vase, and walk around it to find a perspective that you wouldn't normally see. Turn it on its side or flip it upside down. Find an unusual angle such as from below or straight above. Draw a simple sketch of the object, then change the perspective and draw it again. Then again.

This exercise will help you interpret and render an object more realistically and will open up more room for creativity in a drawing.

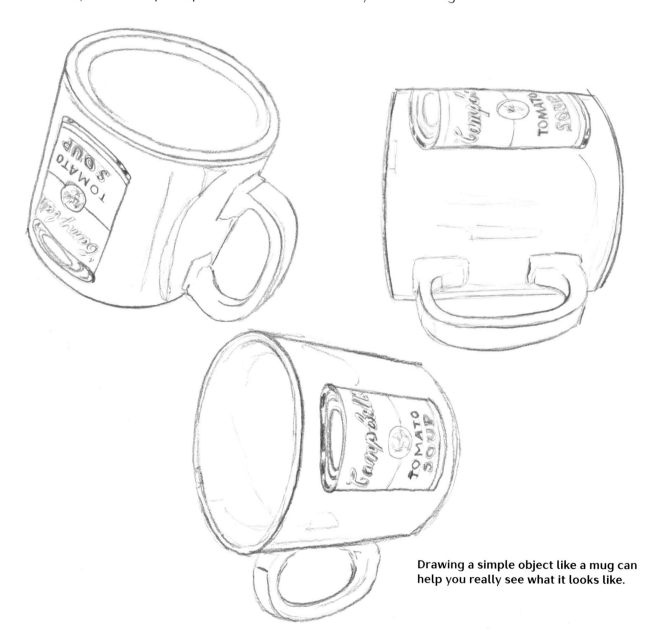

Drawing a simple object like a mug can help you really see what it looks like.

24 Turn It Upside Down

Drawing upside down is an easy way to exercise your ability to draw complex objects. As I have mentioned elsewhere, we don't always draw what we see but what we *think* we see. The act of drawing upside down forces our brains to eliminate their biased ideas, causing us to no longer draw what we "know" but rather what we see. This is because familiar things do not look the same when viewed upside down. When an image is upside down, the visual cues don't match as the brain tries to assign labels to what it sees. Recognizable parts instead become shapes or areas of light and shadow.

The exercise of upside-down drawing is simple: Take a reference image, place it upside down, and draw what you see. Your drawing will also be upside down. Copy the photo just as you see it. You will probably be pleasantly surprised at the results.

This exercise is especially helpful for drawing subjects that may be intimidating, such as the human face. Instead of seeing lips, nose, or eyes, you will see and draw shapes, tone, and other details that are hard to define with labels.

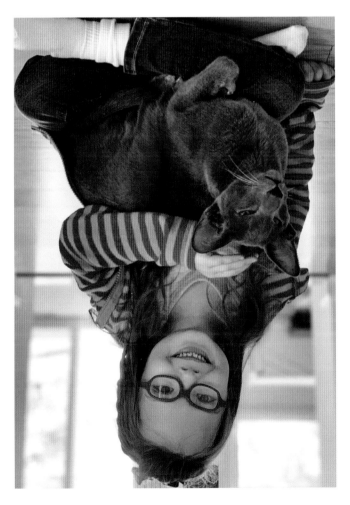
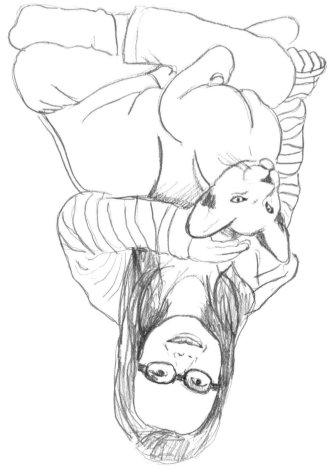

Keep your photo reference and your drawing upside down until you're finished with your sketch.

25 Trace

Tracing can be very controversial among artists. Many artists frown upon transferring a subject using tracing paper, charcoal transfers, or a projector and see it as cheating; however, tracing has been a technique used by artists throughout the years to save time and ensure accuracy. It can be especially useful for new artists learning to observe and place marks accurately. Over time, you may decide not to trace as you acquire more skills with practice. Or you may reserve tracing as a tool that helps save time and ensures accuracy when creating a very technical artwork. After the tracing is done, adding tone, shadows, highlights, or color will make the artwork 100% your unique creation.

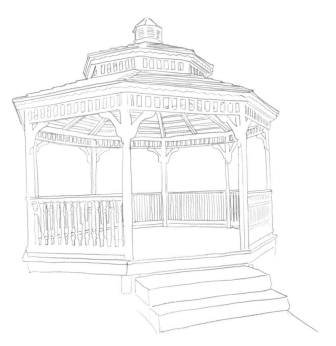

Tracing can be especially helpful when drawing very technical images with lots of small parts, like this gazebo.

26 Use a Grid System

Trying to draw a likeness can be a challenge for any artist, and if you draw realistically, an accurate line drawing is essential. The grid method is an easy way to reproduce or enlarge an image that you want to draw. It also allows you to improve your accuracy while still employing freehand-drawing techniques. To use the grid method, draw equally spaced horizontal and vertical lines over a reference image to create small squares. You can print your reference image and draw the grid lines on it or add them with photo-editing software. On your drawing surface, very lightly draw grid lines with the same proportions as on the reference image. Look at the subject square by square and replicate each square on the work surface.

Quick Tip

Draw your grid lines on your drawing surface very lightly so that you can shade over them to cover them or easily erase them.

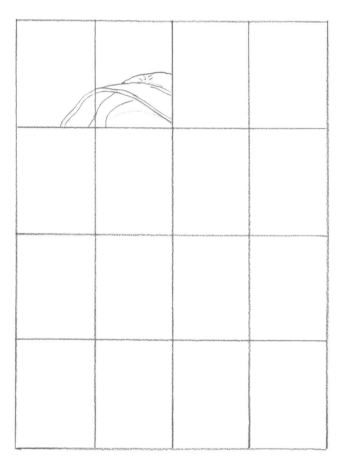
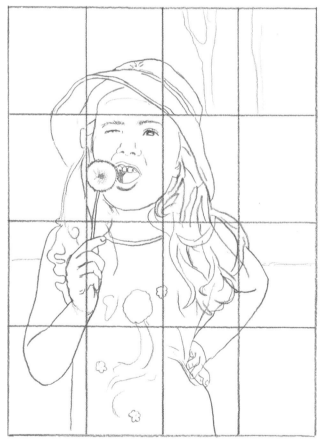

Drawing from a grid is a great way to simplify the drawing of complex subjects while breaking down the drawing process into small, manageable parts.

27 Look at Negative Space

Negative space is the area around a subject and between multiple subjects. The subject is the positive space. Simply stated, negative space is the area of a layout that is left empty. Positive space and negative space work together to achieve balance in a composition.

Negative space can help you when drawing. In a complex drawing, looking at the negative space can often be less daunting than trying to replicate the positive space. It's easier to look at the space around the subject in order to figure out its proportions and placement.

The negative space traces the outline of a subject to reveal its form. By looking at these negative areas, our brains will turn them into simple shapes, which become much easier to draw.

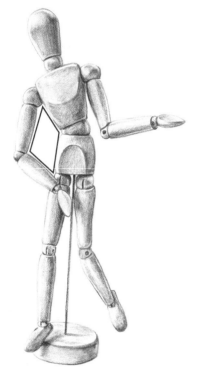

Looking at the negative space created by the manikin's arm turns it into a simple diamond shape that helps to measure the space and check accuracy.

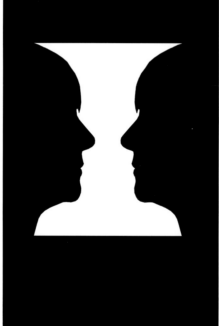

This is a classic example for a reason. It's a perfect illustration of positive and negative space. If you see a vase, then you are seeing the white area as the positive space. If you see the profiles of two faces, then you are seeing the black areas as the positive space.

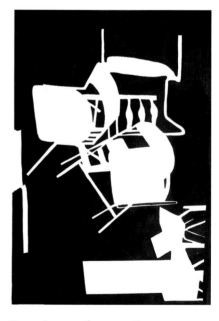

Focusing on the negative spaces around the objects simplifies this very complex still life.

28 Check Your Angles

You need to check the angles of the object you're drawing in order to replicate them appropriately. Oftentimes, an angle may appear to be moving in the opposite direction than it actually is.

To check your angles, hold a pencil or other stick and simply extend your arm to its full length toward the object you're drawing. Place your thumb against the pencil to hold it still. Squint and turn the pencil (side to side, not forward and backward) to line up with one of the lines in the object. Open your eyes fully to look at the actual angle of the pencil, checking to see whether that line matches the direction and angle on your drawing. It can be very helpful to hold a pencil up to a line or an element in the object you're drawing and check the angle.

Quick Tip

An easy way to remember the angle is to think of it in terms of a clock (numbers) or protractor (degrees).

When seen from this angle, the arm of the chair is angled.

29 Measure Up

Use your pencil and thumb to measure the relationships between parts of an object or objects within a scene.

Hold a pencil out at arm's length with the point of the pencil where you want the measurement to begin. Place your thumb on the pencil where you want the measuremen to end. Use that measurement as a standard to compare other areas of the object or scene. This allows the remainder of the work to stay in proportion.

Quick Tip

Keep your arm straight when measuring. If you bend your arm between measurements, they will change.

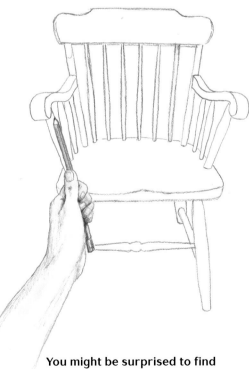

You might be surprised to find that the front spindle on the arm is approximately the same length as the seat of the chair.

30 Use Guidelines

A guideline is a lightly marked line used to establish the size of the object and its placement on the page. Basic geometrical shapes work best. Keep the lines light so you can draw over them or erase them.

Quick Tip

Your lines may not be placed in the exact spot right away—and that's okay. The lines are only guides for where the more permanent lines will eventually fall.

1 To draw a guitar using guidelines, start with a center line to determine the height of it.

2 Block in rough lines for the body and neck to show the approximate size and placement.

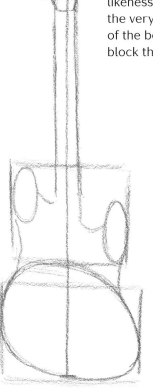

3 With these guidelines in place, you now have a good idea of where to start creating a likeness. Determine the very basic shapes of the body and block those in.

4 Lightly draw more shapes and details seen within the subject, correcting misplaced lines as needed.

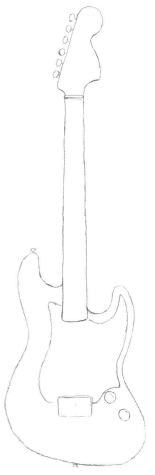
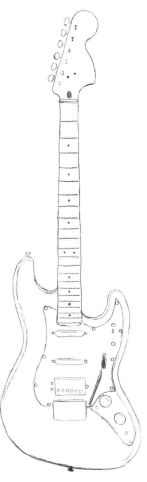
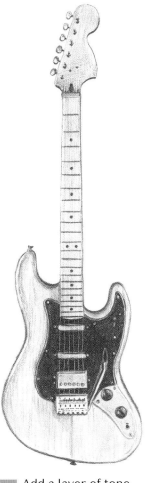
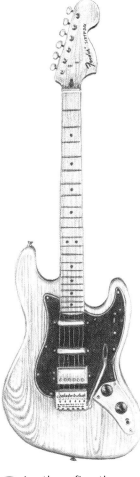

5 Carefully erase any guidelines that are no longer needed.

6 Add finishing details to the drawing, refining and correcting each mark until it resembles the guitar.

7 Add a layer of tone to the subject, pressing harder or using a softer pencil for darker areas. Blend tones to smooth them.

8 Lastly, refine the shading to create contrast and interest. Add textures or patterns for realism.

31 Squint

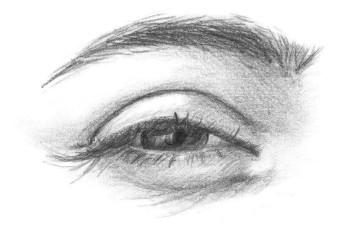

It's easy to get distracted by the overwhelming amount of information provided in a subject you're trying to recreate. A quick way to simplify this information and make it easy to replicate is to squint. When you squint your eyes, the subject becomes somewhat blurred, and a lot of details are removed, which makes it easier to identify essential shapes and values. The basic shapes of objects become clearer, and the spaces between objects appear more like shapes. Remember to squint only at the subject, not the paper you're drawing on!

32 Believe Your Eyes

It's easy to draw what we think an object looks like, rather than what we are actually seeing. Drawing what we think we see involves creating our perception of an object intuitively, without analyzing it in depth, using preconceived ideas of what we think that object should look like. When you look at something, you recognize it for what it is, and your brain categorizes it as a particular object. Your mind has a generic idea of what it looks like.

Drawing what you *actually* see involves analyzing an object's construction, anatomy, proportions, and spatial relationships, while observing the object closely from the point of view from which you are seeing it. To learn to draw what you see, you should focus on the shapes that make up an object, see the contours of the object, and understand the forms they create.

Don't let your eyes be fooled by your common sense.

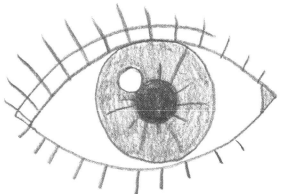

Take this drawing of an eye for example. Our brains tell us that eyes are white on the sides with a dark circle in the middle, but the eyes can be recessed in shadow and are one of the darkest areas of the face.

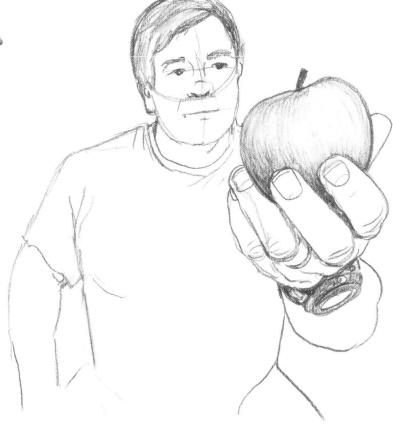

You know the apple is probably not bigger than the man's head but because of perspective, the apple looks bigger. Don't let your brain talk you out of drawing what you actually see.

33 Change Your Shapes

Because what we think we know about how an object looks and how it actually appears can vary dramatically, we know that we have to draw what we see. Certain shapes change depending on the angle from which we view them. If you look at a cylindrical object like a mug, the top (opening) and bottom are circles. But unless you're drawing the object looking straight down on it, the circles get squished and become ellipses (ovals), because of perspective. All shapes will appear distorted to some degree unless we are looking at them straight on.

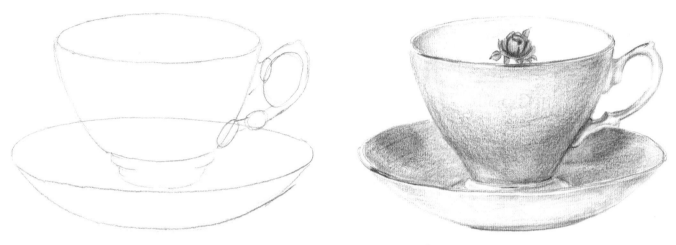

The top and bottom of this teacup as well as the saucer it sits on are perfect circles. But when looking at them from the side, those circles become ovals.

When you look at a table from different points of view, the shapes will likely change. The top of this table is a rectangle, but because we're viewing it from an angle, it widens and becomes a trapezoid.

34 Draw "Through" an Object

While it may be tempting to draw just the portions of the objects that are seen, that may be a mistake. It is actually quicker (and easier) to lightly sketch out the front and back of an object so it looks proportionately correct. This helps with accuracy and gives a feeling of solidity even after the unseen lines are erased. Once an item is placed in front of this shape, the overlap will offer a satisfying sense of realism and depth.

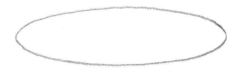

1 Draw an ellipse for the top of the pot. The back of it will eventually be covered.

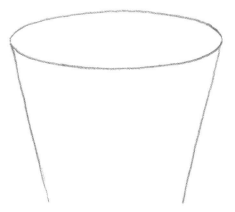

2 Add two slightly slanted lines for the sides.

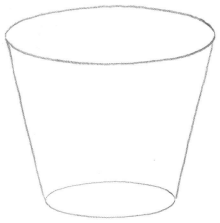

3 Add a smaller ellipse for the bottom of the pot. This line will be erased in a later step.

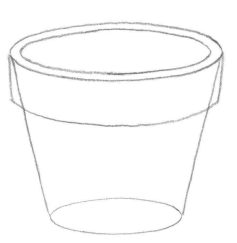

4 Draw the rim of the pot.

5 Erase the back of the bottom ellipse and the lines that are covered by the rim.

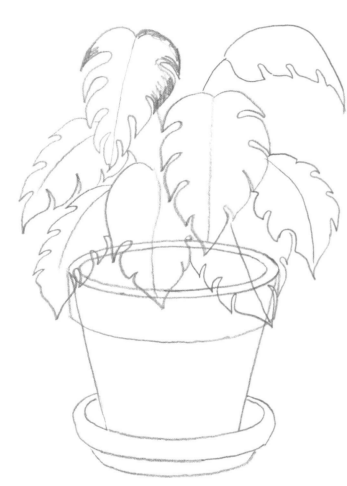

Quick Tip
You can also sketch in the entire back leaves, then erase the lines that are covered by other leaves.

6 Lightly sketch in the leaves, and add the dish the pot is resting in.

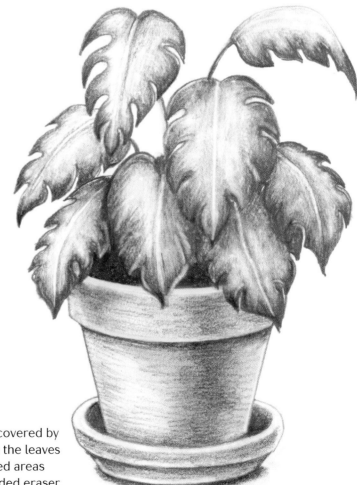

7 Erase the back rim that is covered by leaves. Add overall tone to the leaves and pot, then darken the shaded areas and add highlights with a kneaded eraser.

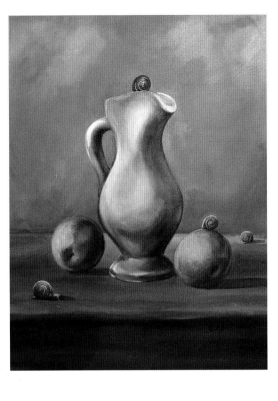

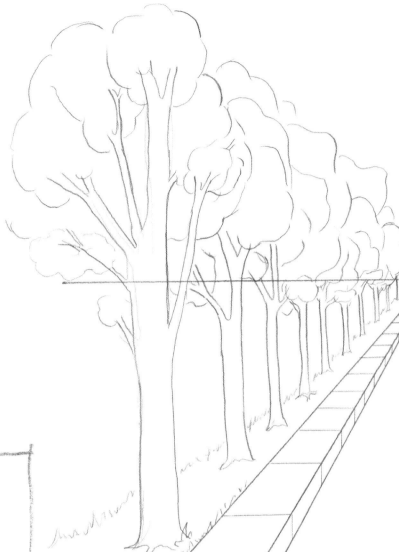

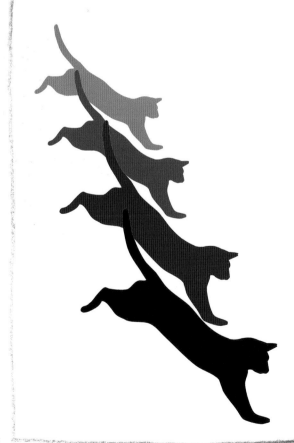

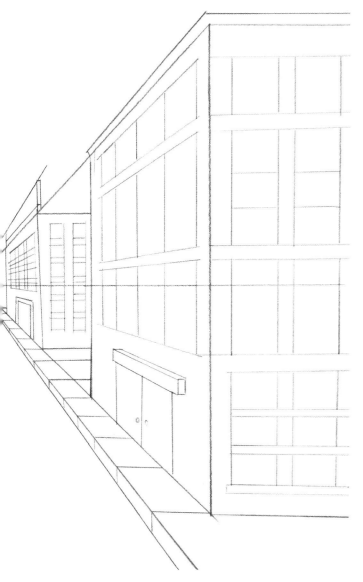

CHAPTER 3

Create Stronger Compositions

Once you're comfortable capturing a likeness, you're ready for the next step: creating drawings that capture viewers' attention and keep them looking. It's all about arranging the elements of your drawing effectively to best showcase your subject and create impact. Luckily, there are many tried-and-true "rules" of composition and handy tricks to help simplify it.

Trees
and
stones
will
teach
you

what
you can
never
learn
from
masters

St. Bernard

35 Create a Strong Composition

Composition is the arrangement and organization of visual components in an artwork. It gives the work structure and conveys the thoughts of the artist. The principles of design or art are a set of criteria in which the elements of art are organized in a work, influencing the composition. You don't have to use all of them in every piece of art you create, but understanding and applying them will improve your compositions and how you communicate with your viewers.

Balance

Balance creates visual stability. Your artwork can be symmetrically balanced, in which each half of the artwork is identical or similar, or asymmetrically balanced, in which each half is different but has equal visual weight. It can also show radial balance, in which equal parts radiate out from the center.

Pattern

Pattern refers to the visual arrangement of elements with a repetitive form or intelligible sequence. For example, you can use an interlocking motif to pull the viewer's eye throughout the artwork.

Emphasis

Emphasis is a way of using elements to stress a certain area in an artwork, drawing attention toward a focal point (see Secret #37). You can do this by contrasting different elements against each other or showing dominance to one part in some other way.

Contrast

Contrast simply means a difference. By highlighting differences such as light against dark, warm against cool, rough against smooth, and large against small shapes, you can create visual interest, excitement, and drama.

Variety

Variety refers to the use of differing qualities of the visual elements throughout a work, contrasting components within a composition. Try placing different visual elements next to each other to create variety.

Unity

Unity, or harmony, refers to how well all the visual elements work together in a work of art. Make sure that the elements have some kind of logical progression or relationship, giving the artwork a sense of consistency.

Movement

Movement is used to create the impression of action in art. You can arrange shapes in a way that leads the viewer's eye from one point to another or use certain techniques to mimic movement.

Scale and Proportion

Scale relates to the size of an object compared with the space it occupies, while proportion is concerned with the relationship of elements to one another and to the whole. Pay attention to both as you plan your compositions.

36 Apply the Rule of Thirds

The "rule" of thirds is more of a guide than a rule to finding interesting areas to place focal points in a composition. The idea is to place the focal point where it will create the most interesting and dynamic composition. Before creating a composition, lightly draw two equally spaced horizontal lines on the surface followed by two equally spaced vertical lines. The result should resemble a tic-tac-toe board since the canvas has been divided into nine equal parts. These lines serve as a grid that creates four points where the lines intersect. Now that the surface has been divided evenly into thirds, both horizontally and vertically, you can place objects of main interest in these intersections in order to make the most pleasing composition. Applying the rule of thirds helps draw the viewer's eye into the image and places more emphasis on the subject while the design is made striking and effective. This is much more appealing than dead center.

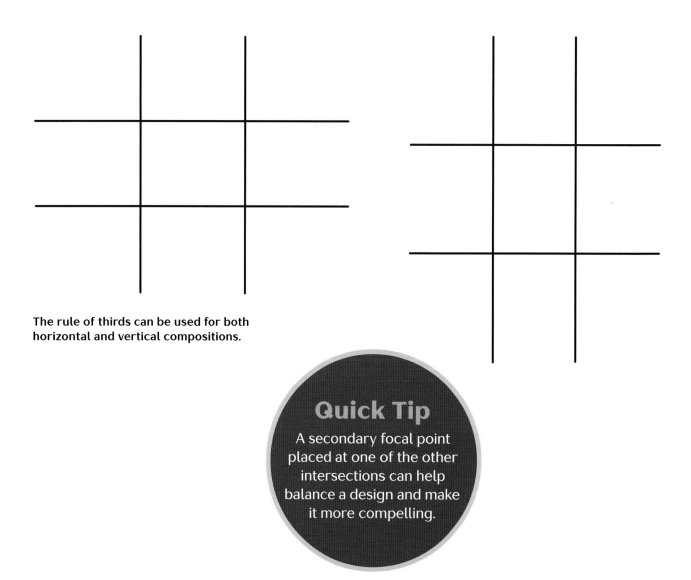

The rule of thirds can be used for both horizontal and vertical compositions.

Quick Tip

A secondary focal point placed at one of the other intersections can help balance a design and make it more compelling.

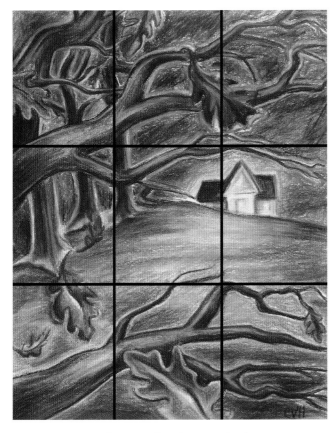
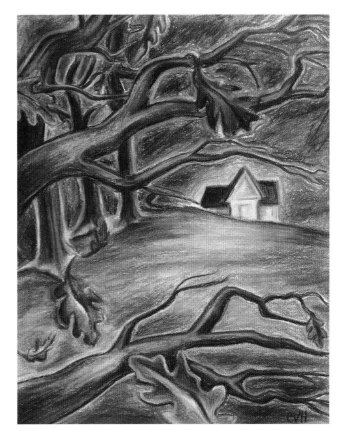

In this drawing, the main focal point (the house) is placed near an intersection. The secondary points of interest (branches) fall across intersections as well, and the direction of the trees leads the eye from one focal point or intersection to another, creating movement.

Placing the boat at an intersection of lines creates much more interest, tension, and energy than if it were simply centered.

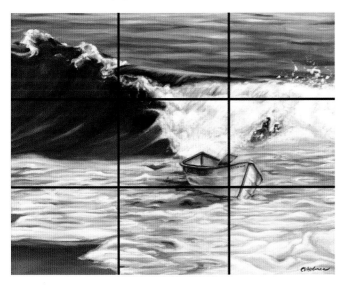
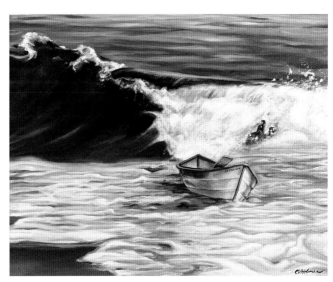

37 Choose a Focal Point

The focal point of a painting or drawing is the area in the composition where the viewer's eye is naturally drawn. A specific place of visual emphasis gives an artwork a direction or purpose. This area of interest that commands attention could be the subject, but it doesn't have to be. It is not essential to have a focal point in an artwork, but it can help give an artwork direction. You're not limited to just one focal point in an artwork. There may be two or three parts that need to be highlighted, but remember that a variety of focal points will compete for attention. If more than one focal point is needed, one can be made the primary focal point while the others can be secondary.

Ways to Create Focal Points

A focal point can be approached in several ways.

- Create contrast, such as light and dark, color, texture, or size, between one object and the rest.
- Isolate one object away from others or show a solitary object on a plain background.
- Use the rule of thirds (see Secret #36).
- Create real or implied lines that point toward the main object. This is called convergence.
- Develop the focal point by drawing one area in sharper focus.

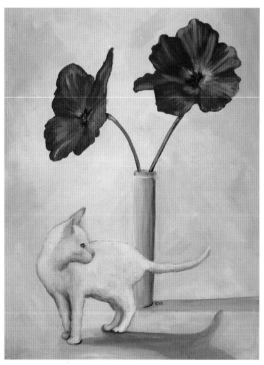

The placement of the cat using the rule of thirds and the lines created by the stems of the poppies that lead the eye to the cat make the cat the focal point.

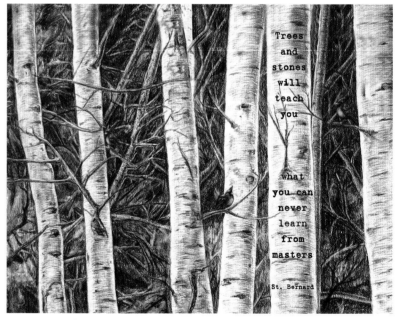

You are not limited to just one focal point. Here the cardinal at top right is the main focal point because of its position and its proximity to the quotation.

38 Use Warm and Cool Colors Effectively

Color is powerful. It is stimulating, healing, and soothing. The colors you choose to use can cause mood changes, create light, alter perception of size, or be a source of information. An artwork will create different energy depending on whether it contains warm colors, cool colors, or combinations of both.

Warm Colors

Colors such as red, yellow, and orange evoke the feeling of warmth because they remind us of the sun and fire. The wavelengths of these colors are long and are easily noticed, putting them at the forefront of an artwork, as these hues actually appear closer to the viewer. Warm colors offer a bright, radiant, revitalizing, boosting effect. They convey optimism, enthusiasm, and passion.

Cool Colors

Colors such as blue, green, and purple evoke a feeling of coolness because they remind us of things like water or grass. They are commonly found in nature and are known for their calm, meditative, and soothing effect. They are usually found in the background of an artwork, since those colors make things appear farther away.

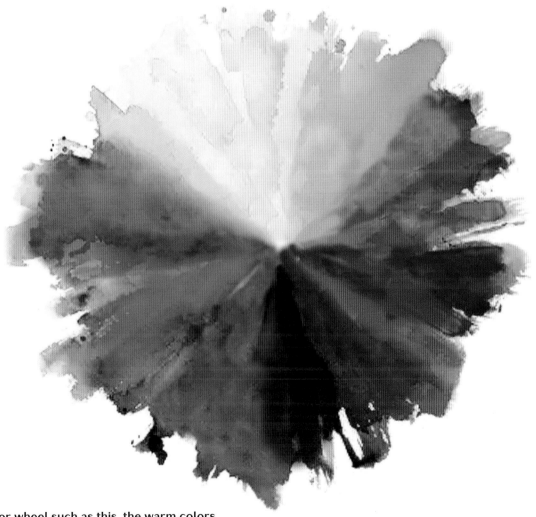

In a color wheel such as this, the warm colors of red, orange, and yellow are opposite the cool colors of blue, green, and purple.

39 Don't Forget the Background

When we draw, we often concentrate on creating the focal points within the artwork and think of the background as secondary or neglect it altogether. The background is a vitally important part of the work and shouldn't be an afterthought.

There are several types of backgrounds you can use:

- The first type is none at all! If there is empty space around an image, it can still create a certain mood or story. Try this when you want the viewer to focus on the subject.

- A vignette a picture that doesn't have a definite border. The background is filled with a single tone, leaving blank areas at the edges of the picture. This is a good option to use if the background is too bright or you need some tone to highlight or contrast with the main subject.

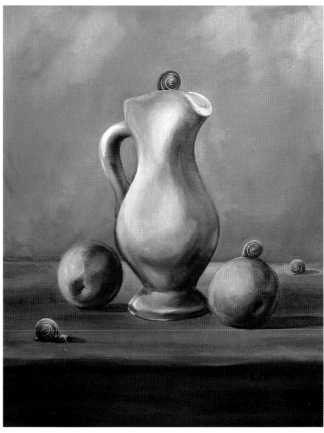

This variegated background has muted cool tones that allow the vase to subtly stand out.

A simple vignette grounds the subject and softens the edges of the sculpture.

- A simple variegated background with just a variety of tones may be suitable if you want the focus to be on the main subject but some detail is needed in the background to balance it out.

- Backgrounds can also be much more detailed. They can even have as much detail as the foreground.

- Finally, the "background" can be the main subject, as in some landscape paintings and drawings.

- Whatever background you choose, it should complement the main subjects, not compete with them.

40 Simplify!

Simplifying a subject into basic shapes is a fundamental skill. This just means using artistic license to eliminate unnecessary aspects of an image when drawing it. Sometimes you're limited by time and can only create the essence of a character or an object, so simplifying is imperative. Other times, you may intentionally leave parts of an artwork less detailed so the focus can be placed elsewhere.

This may mean breaking a complex image into dark areas and light areas by focusing on shadows and highlights. It may also mean blending minute details together, such as leaves on a tree.

You should consider exactly the mood you're trying to evoke and determine what details are important to the story, simplifying the rest. If something is not the focus of the artwork, simplify or eliminate it. Remember that there only needs to be enough detail for the audience to understand what is going on. Viewers will actually provide their own conclusions.

By simplifying, you're rendering an object in unusual ways and creating visual surprise.

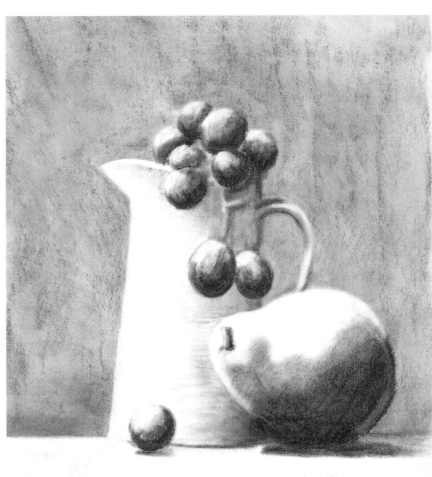

In this still life, I focused on creating forms with shadows and highlights and omitted unnecessary details.

41 Crop It

Cropping is the removal of unwanted or unnecessary outer areas from a subject so it contains only those elements that are crucial to the work of art. Decisions about cropping are best done in the planning stage when you are considering a reference image or scene to draw. Cropping is an important part of composition, as it can remove distractions, unwanted subjects, or irrelevant details. Cropping can also help put the center of interest where it belongs. Deciding on what to crop and whether or not to crop is an aesthetic decision. Things to consider include the optimal placement of the main subject, the contact of the subject to the edges of the work, the need to eliminate distractions, and the appropriateness of the final canvas/surface shape to the subject matter.

Quick Tip

Not sure whether your subject will look good cropped? Using a camera viewfinder can help you see what your image will look like in order to get the best view to draw.

In all of these paintings, cropping the scene put the focus on the most important areas of the composition, using the rule of thirds (see Secret #36).

42 Use Foreshortening

Foreshortening is a perspective technique that reduces or distorts part of an object to create the illusion of parts receding into the background while other parts emerge as larger in the immediate foreground. Simply put, if a part of an object is very close to the viewer, it will appear quite large. If another part of the object is farther from the viewer, it will appear much smaller.

Foreshortening affects the length of every single body part. Anything that comes toward the viewer will be distorted to a degree. Being able to accurately draw objects jutting forward or receding into space will make a drawing appear more realistic.

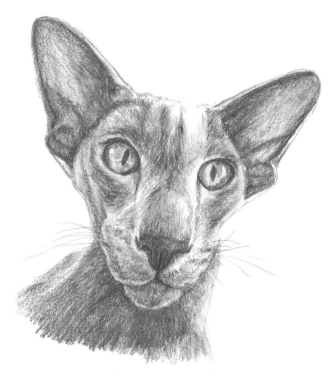

Although Dexter's nose is larger than most cats' due to his breed (Oriental shorthair), the nose in this drawing is exaggerated and looks much larger than it really is compared to other parts of his face.

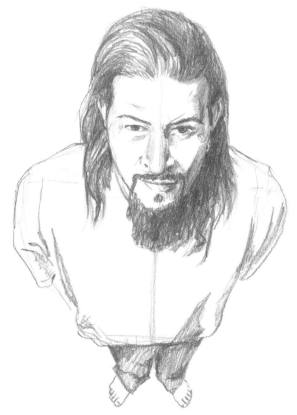

The same happens when a figure is viewed from above, except this time, the head appears to be the largest part of the drawing since it is closest to the viewer.

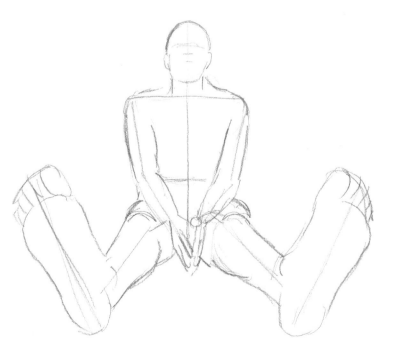

When viewed sitting with feet protruding out, a figure appears distorted. Since the feet are closest to the viewer, they have been drawn larger and the legs look shorter.

43 Learn One-Point Perspective

Perspective a technique artists use for representing the illusion of three-dimensional volumes in a two-dimensional drawing, shown from the viewpoint of an observer. Objects appear to get smaller and closer together the farther away they are from the viewer or larger and farther apart as they move closer.

One way to create perspective is to start with a vanishing point. This will be the spot in an artwork where seemingly parallel lines will converge. The vanishing point is usually found on the horizon line, the line that runs across the paper to represent the viewer's eye level or delineate where the sky meets the ground.

When you look down a long, straight road, the edges of the road give the illusion of meeting at a point on the horizon. This is one-point perspective because you have one vanishing point.

All lines used to create the main objects will either be parallel to the paper edges or will recede toward the vanishing points (receding lines).

Use a ruler for best results.

Vanishing point

Horizon line

Receding lines

Quick Tip

To ensure that your ruler doesn't move while you're drawing lines, hold it down flat, touching one end to point A and the other to point B. Spread your fingers out over the ruler.

1 Start with a horizon line and a vanishing point. Draw receding lines for the street (should look like a triangle). Bring the base of the triangle to the bottom of your paper.

2 Draw lines on either side of the triangle coming from the vanishing point. This will be a sidewalk. Draw two more straight lines much closer to the sidewalk for the curb edge.

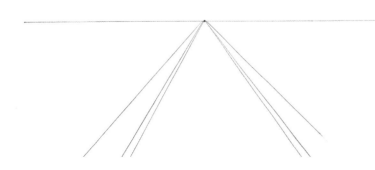

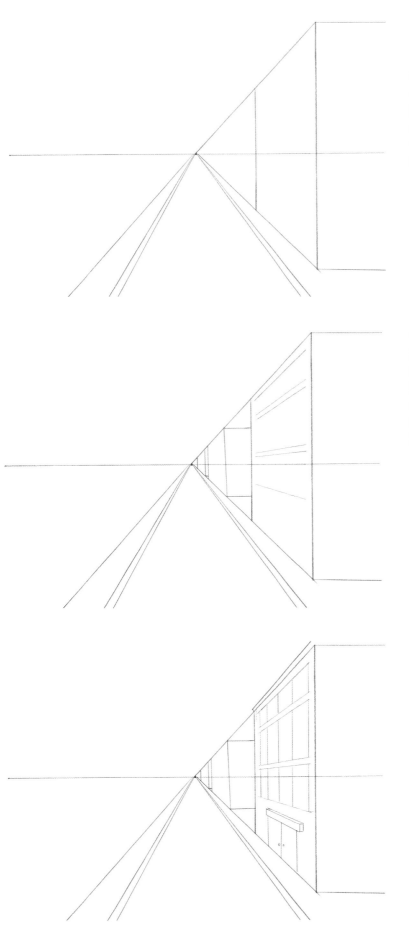

3 Draw a rectangle on the far right of the page. This is your first building. Draw a line from the corners of the rectangle to the vanishing point. Draw a vertical line between the receding lines to show the far end of the building.

4 Make a rectangle shape similar to the one in Step 3 to create a new building. Use the receding lines already in place as the top and bottom of the building. Repeat this step to draw a row of buildings. Use the vanishing point to help draw lines on the side of the buildings for windows.

5 The vertical lines for the windows should be parallel to the sides of the paper.

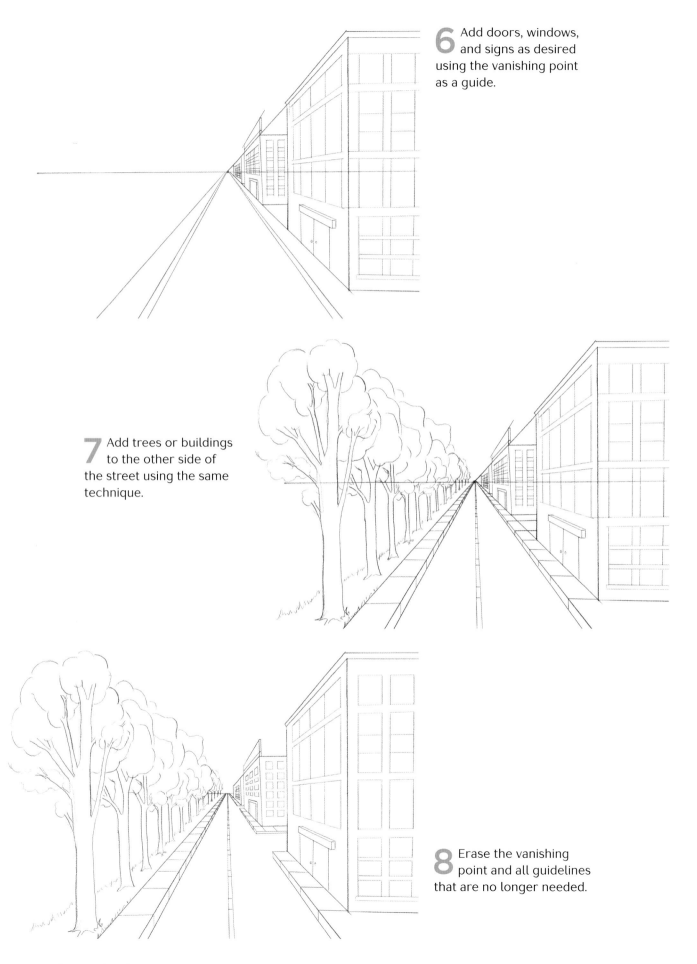

6 Add doors, windows, and signs as desired using the vanishing point as a guide.

7 Add trees or buildings to the other side of the street using the same technique.

8 Erase the vanishing point and all guidelines that are no longer needed.

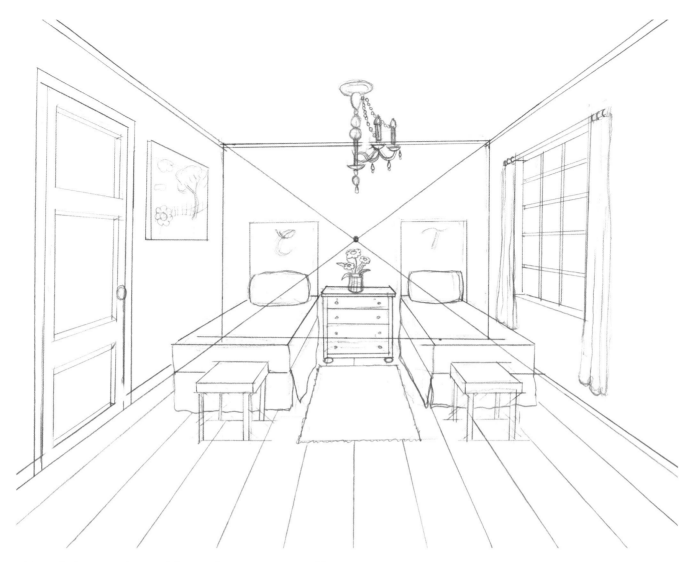

This technique can be used for outdoor scenes as well as interiors. Here, the receding lines are used to draw not only the structure of the room's walls, but also the objects in the room.

Quick Tip

Once you understand and practice using one-point perspective, you can vary the heights of the buildings and create a much more complex drawing.

44 Use Two-Point Perspective

Two-point perspective drawing is another type of perspective that uses two vanishing points (not one) placed on the horizon line. It is often used to draw buildings and can be used with interiors as well. Here's how to use it to make your drawings more realistic.

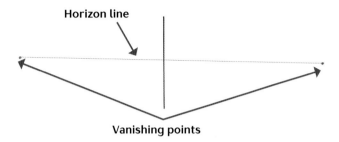

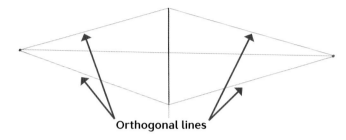

1 Place two vanishing points at either end of a horizon line. The placement of the points will determine how short or long edges of objects will be in the artwork as well as indicate where objects begin to disappear. Draw a single, vertical line to be the corner of the cube you will be drawing.

2 Draw lines from each end of the vertical line to each vanishing point. These lines are called orthogonal lines. The distance above and below the horizon line from which the orthogonal lines start is determined by how sharp of an angle you want the object to show.

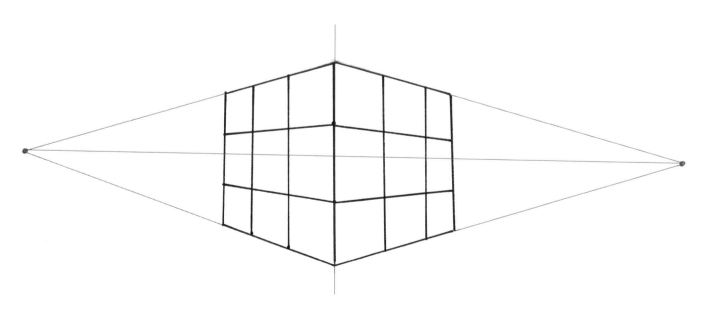

3 Draw parallel, vertical lines to indicate where a shape on the cube begins and ends. The closer these lines are to the vanishing points on either side, the longer the form appears. Draw lines from the vanishing points to the original vertical line to indicate the tops and bottoms of these shapes.

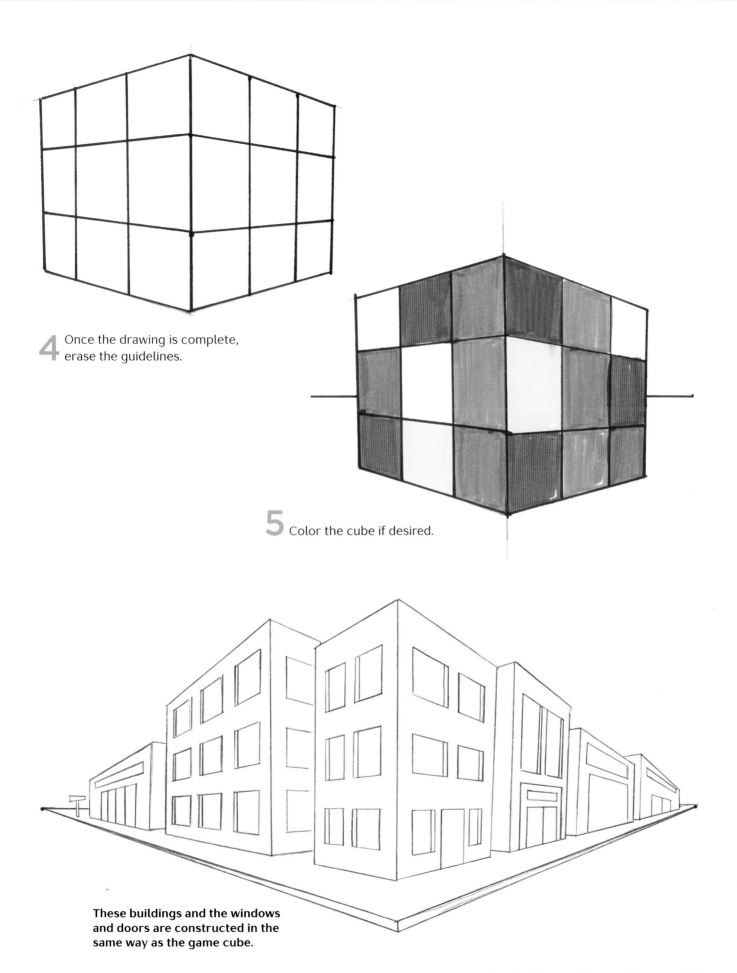

4 Once the drawing is complete, erase the guidelines.

5 Color the cube if desired.

These buildings and the windows and doors are constructed in the same way as the game cube.

Create Stronger Compositions 63

45 Practice Perspective

Generally, the closer an object is to a viewer, the larger it should appear in order to look more realistic. It is also usually lower in the composition. The farther away an object is, the smaller and higher up it should appear on the drawing surface. It is also usually lighter and softer in tone and less detailed.

Here is a fun exercise to practice these principles.

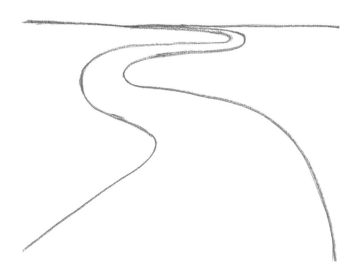

Quick Tip

Whether you're doing this in color or black and white, tones should be darker the closer they are, lighter the farther away.

1 Start with a curving "S" shape on your paper. This shape should be large and wide at the bottom of the page and narrower toward the top. Indicate the horizon line with a brown line. Color the river if you wish.

2 On a separate piece of paper, draw three variations of the same object. Here are trees: one small, one medium size, and one large. Cut them out.

3 Fill in the background as desired, having fun with colors and tones.

4 Place the tree cutouts on the background scenery. The largest tree should be lowest on the page, the medium-size one should be higher but still below the horizon line, while the smallest should be the highest object on the page.

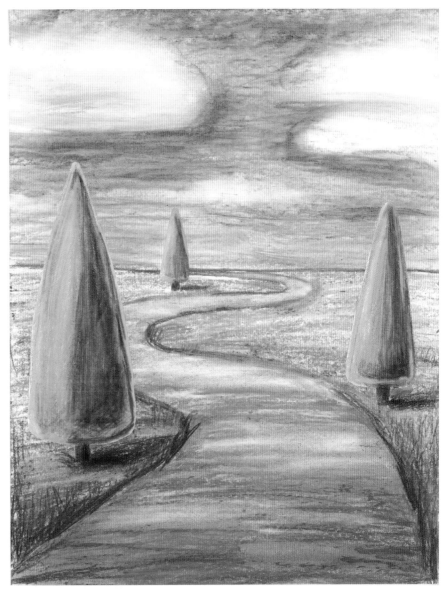

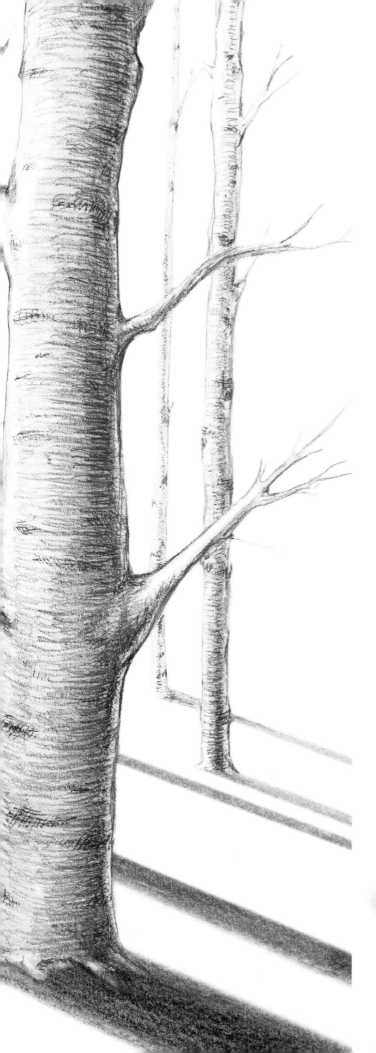

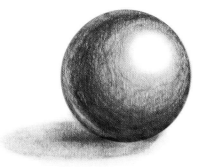

CHAPTER 4

Make It Real

Once you know the secrets of creating an accurate rendering and a strong composition, it's time to add depth and interest to your work. It's like the frosting on a well-made cake. In this chapter, you'll learn about creating volume with shading, line quality, blending, conveying motion, and many more valuable—and rewarding— techniques that will take your drawings to the next level.

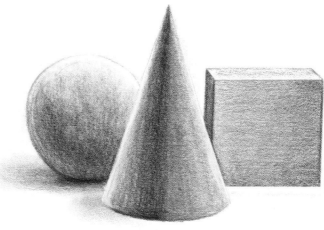

46 Focus on Line

Line is one of the seven elements of art (see Secret #8). Although it may seem simplistic, there is a lot of power in line. Line drawings can be sketches or a means for getting an outline onto paper to identify edges of objects, but they can also be finished artworks unto themselves. Line art can be very descriptive and beautiful in its own right, showing form and dimension without the need for shadows, highlights, or texture. Line art can be abstract or representational and include straight, curved, thick, and thin lines. Line art is often black and white, but not always.

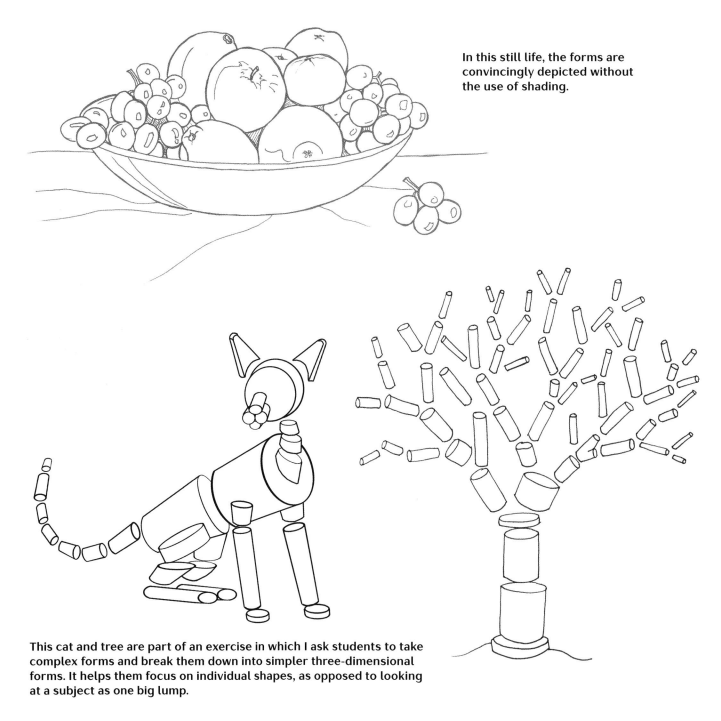

In this still life, the forms are convincingly depicted without the use of shading.

This cat and tree are part of an exercise in which I ask students to take complex forms and break them down into simpler three-dimensional forms. It helps them focus on individual shapes, as opposed to looking at a subject as one big lump.

47 Use Line Quality

Line weight refers to the visual thickness, thinness, lightness, or darkness of a line within a drawing. Line quality refers to the interaction of different line weights used to communicate depth, importance, and proximity in an artwork. A variety of line quality heightens the descriptive potential of an object. Textures, movement, light, space, form, balance, etc. can be defined through the proper distribution of line weight.

Typically, we see objects closer to us in great detail, meaning that lines will have a greater range of value, thickness, and character. You may want to vary their lines to define an object's edges using thin, hard, lost, and undefined marks. Lines may become wider or thicker in areas where the object itself is thicker, or they may become thicker to indicate an area in shadow. Other lines may be drawn thinner to represent areas that are receding toward the background or highlighted.

This drawing does not show any line quality. All the lines have the same weight and barely differ from one to the other.

This drawing employs a variety of line weights that imply space and light, while making it more interesting to look at.

Ways to Create Line Weight

Line weight can be created in several ways:

- You can use more pressure. Less pressure on the tip of your drawing tool will leave a light line, while more pressure will create darker lines.
- Going over the lines two or more times will make them heavier.

- The angle of the tip can also alter line weight. If you hold the tip of the tool at an angle, more of the tip comes in contact with the surface.
- You can use a softer (darker) pencil or a thicker pen to increase line weight. Feel free to use a variety of pencils or pens in the same drawing.

48 Try Continuous Line Drawing

In art, line identifies edges, defines form, creates tonal variation, and leads the eye from one part of a work to another. Continuous line drawing is an excellent way to exercise the use of line while observing its necessity. In continuous line drawing, an artist draws an object with one single, unbroken line, without lifting the pen or pencil from the paper during the entire duration of the drawing. This drawing method develops confidence while encouraging your brain and eye to collaborate. To begin, place the drawing tool anywhere on the paper. Start drawing what you see, keeping the line flowing. Be sure to draw outside edges as well as internal shapes. Feel free to draw through the forms and overlap if necessary in order to complete a shape or part of the subject. This may make the work less precise or realistic, but it will convey action and emotion.

Quick Tip

To avoid the temptation to erase lines, use a pen, thin marker, or other tool that permits a free-flowing line.

It's amazing how one unbroken line can depict so many textures, details, and patterns.

49 Create Form with Shading

Shading is used to create the illusion of depth in a two-dimensional medium. Shading uses value (the lightness or darkness of a color) to give a two-dimensional drawing the appearance of a three-dimensional form. It also helps tdefine the edges of an object.

The area where the light source directly hits is the lightest area and is called the highlight.

Directly opposite the highlight is the core shadow, the darkest part of the object. It receives the least amount of light.

The area between the highlight and the core shadow is called the midtone.

On the edge of the sphere is a sliver of reflected light that can brighten areas of the subject that are in shadow and help define it from its background.

Finally, the cast shadow on the surface reinforces the direction of the light source and enhances the three-dimensional feel of the object. The part of the cast shadow where the object meets the surface is the darkest spot.

Quick Tip

When shading a sphere or other object, make sure the transition between tones is gradual.

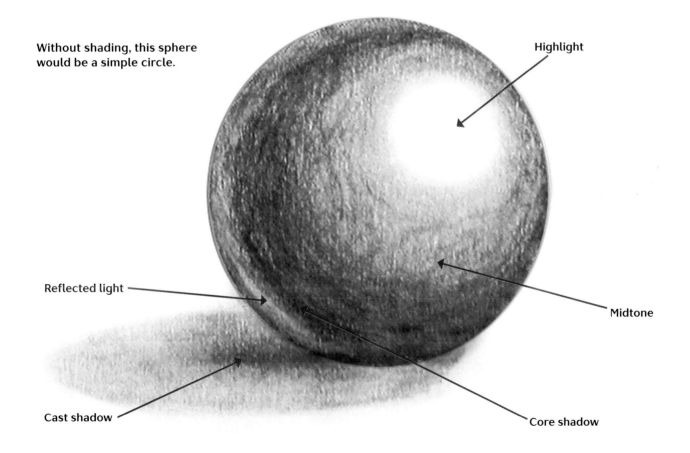

Without shading, this sphere would be a simple circle.

Highlight

Midtone

Reflected light

Cast shadow

Core shadow

50 Know Your Light Source

Creating light and shadow is the most effective method of making a drawing appear three-dimensional. Understanding how forms behave in different lighting conditions can help achieve added realism in a work of art. It's all about being aware of where the light is coming from and making sure it is consistent throughout your drawing.

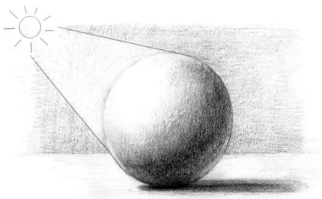

Draw a small sun like this on your paper to remind you to pay attention to the light source.

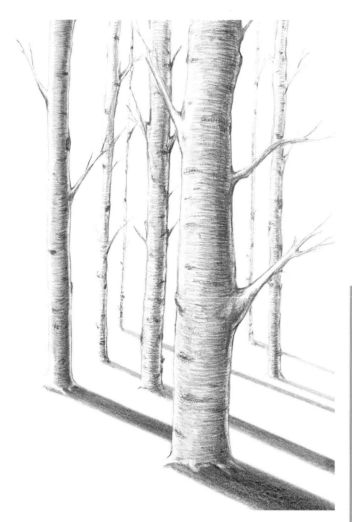

Here, the light is coming from the left, causing shadows to fall to the right.

More About Light Sources

- Mark the direction from which the light source is coming on your paper as a reminder. A small, sketchy sun or light bulb will work.
- Light may come from many sources and angles, such as a window and a lamp, which can be confusing. Try to use a single light source so it behaves predictably.
- Check to make sure that the highlights and shadows made by the light are always directly in line with the light source.
- If the light source is directly above the object, it will cause a short shadow shape directly under the subject. When the light source is to the side of a subject, more interesting, longer shadows are created.
- When possible, plan out your artwork and manipulate where you want the light source to create the most compelling composition. This may mean waiting for the sun to move lower in the sky or moving a lamp to create the desired effect.

51 Employ a Range of Values

Value helps us create believable space, form, shadows, highlights, and mood within our pictures. Value in art is essentially how light or dark something is on a scale of white to black. The scale consists of light values, a middle value or midtone, followed by dark values. The number of values between white and black are infinite, but we usually reduce the range to a scale between five and ten.

When we draw with value, we mimic the way that light falls on a form to create the illusion of three-dimensionality. If you do not accurately represent the relationships between the values of an object, you will not create a convincing drawing.

A successful artwork uses a range of values: ample amounts of light values called tints and dark values called shades.

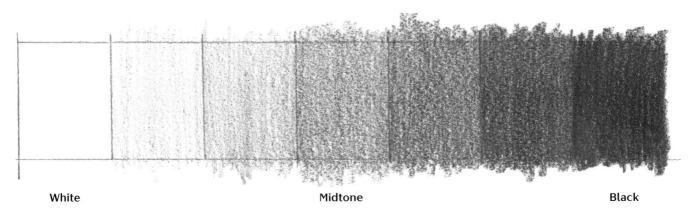

White Midtone Black

You can use a value scale as you work on a drawing, identifying specific values and adding them in appropriate spots.

52 Know Your Blending Tools

A blending stump is felt paper that is tightly rolled up into a solid wand with two pointed ends. This tool works well for blending large areas that require detail and control.

A tortillon has only one pointed end and is typically narrower and shorter than a stump. It is great for shading in fine areas where precision and detail are important.

Almost anything can be used to blend tones into one another in an artwork. Some other blending choices are (but aren't limited to) cotton balls or swabs, chamois, fabric, or fingers.

Blending stump

Tortillon

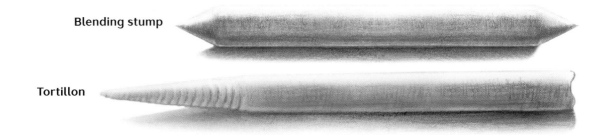

53 Layer Your Shading

Shading is one of the easiest ways to add depth, contrast, character, and movement to your drawings. It is not a difficult skill to learn, but it does take some practice. By controlling pencil pressure and stroke, understanding light, and having a knowledge of blending techniques, you can enhance your work and offer the wow factor needed in order to make an artwork convincingly realistic. To develop realistic methods in pencil shading, and a style of your own, you will need to learn how to shade in layers.

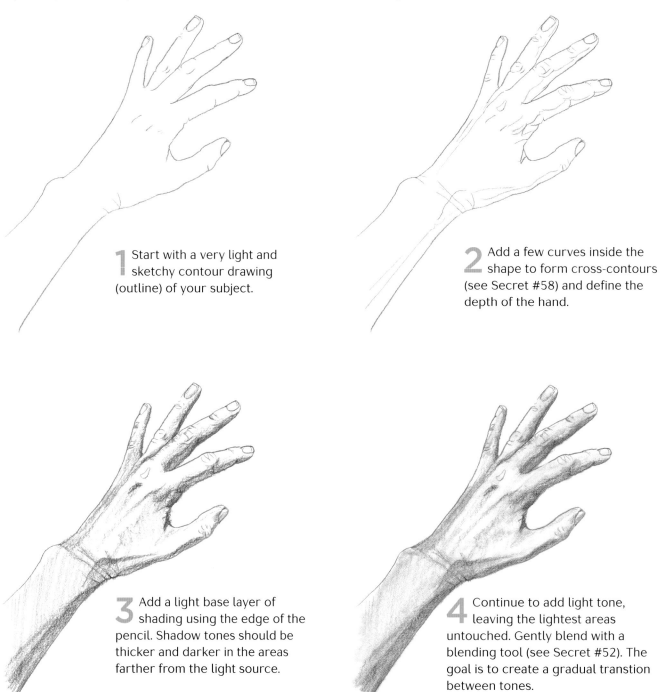

1 Start with a very light and sketchy contour drawing (outline) of your subject.

2 Add a few curves inside the shape to form cross-contours (see Secret #58) and define the depth of the hand.

3 Add a light base layer of shading using the edge of the pencil. Shadow tones should be thicker and darker in the areas farther from the light source.

4 Continue to add light tone, leaving the lightest areas untouched. Gently blend with a blending tool (see Secret #52). The goal is to create a gradual transtion between tones.

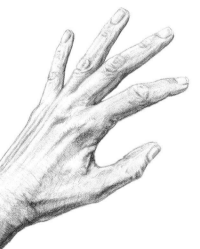

5 Use a kneaded eraser (see Secret #5) to take away pigment from the highlights and areas near the light source.

6 Go back and add another layer of tone. This may mean using a softer, darker pencil (e.g., changing from a 2B to a 6B pencil). Add small texture details with line.

7 Intensify highlights by using the kneaded eraser to remove pigment from the areas closest to the light source. Add more texture details.

54 Vary Your Shading Marks

You don't just have to add smooth, blended strokes to a form to shade it. Try one or more of these shading techniques to produce a different texture or mood in your drawing.

Hatching uses closely spaced parallel lines. The denser the lines, the darker the shading appears. All the lines go in the same direction.

Crosshatching starts with hatching and adds another layer of lines over the first at a right angle. Varying the direction of the lines and layering them helps obtain different intensities of shading.

Stippling is a pattern of small dots. It is very time-consuming but can create stunning visual effects.

Contour hatching is made up of lines that follows the shape of the object you're drawing.

Scumbling uses layers of small, scribbled circles to build up value and texture. Varying the direction can add more interest.

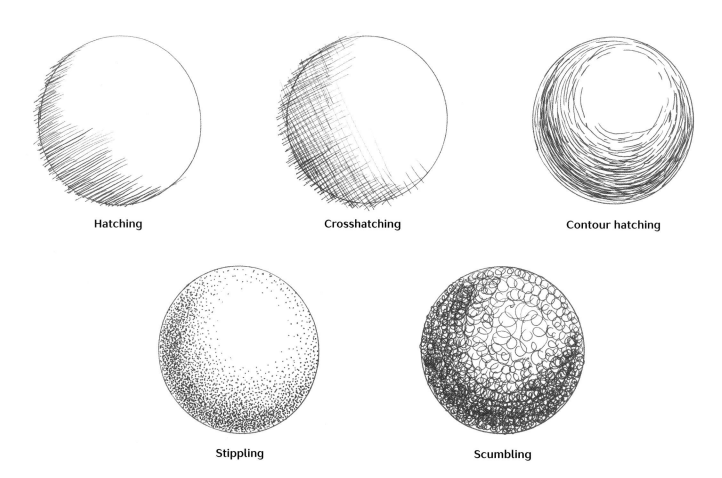

Hatching Crosshatching Contour hatching

Stippling Scumbling

55 Blend Your Tones

Blending is the technique of combining two or more values to create a gradual transition of tone or to soften lines. You can use a variety of blending tools ranging from professional tortillons and blending stumps to cotton swabs, tissues, chamois, and fingers. You can also use a blending tool to help create the illusion of textures in an object. Some artists choose not to use a blending tool, but instead create smooth transitions by adjusting the pressure on the pencil. Blending can be very helpful to use when trying to achieve depth and lifelike shadows; however, there is a danger of over-blending. When tones are over-blended they lose the contrast created with a pencil, making the darks and lights smudge into muddy gray tones. Blend lightly, as you can always blend more later!

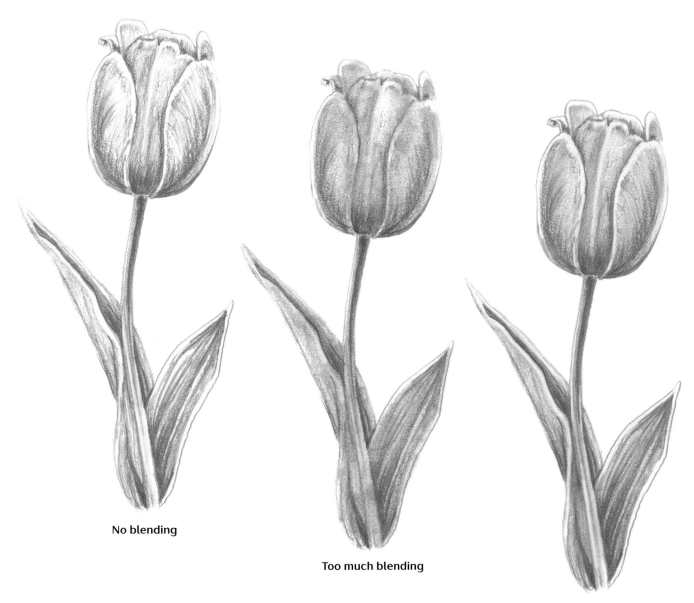

No blending

Too much blending

The right amount of blending makes the drawing look natural but not too soft.

56 Use Value for Contrast

Even when working in color, you still have to pay attention to value. Value is a much more powerful structural element in your artwork than hue. Two colors from opposite sides of the color wheel are thought of as contrasting, or complementary, colors. They often clash or feel unsettled next to each other. But when converted to black and white, their spatial effects flatten out and the contrast virtually disappears.

Remember that colors also have value and that every color has a range of values. If you want to have contrast in your artwork, you have to use colors that have different values, not just contrasting hues.

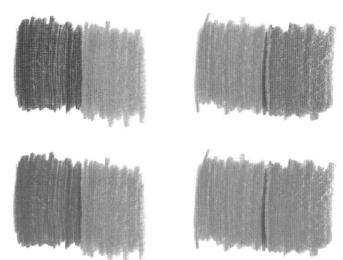

When contrasting colors are converted to black and white, the differences can disappear if their values are too similar.

57 Vary Pencil Pressure

To vary the darkness of a mark, you must change the amount of pressure as you draw or add tone. Varying the pencil pressure can create a multitude of different effects, which will create interest and more realistic images.

Deciding where to add more pressure depends on the subject matter. Consider the texture, highlights, and shadows of the subject and how those can be duplicated with the marks you make.

The speed, direction, and weight in which a line is drawn will change the look of the line. Dark lines made with heavy pressure appear bold and distinct, while light lines made with lighter pressure are distant and sketchy.

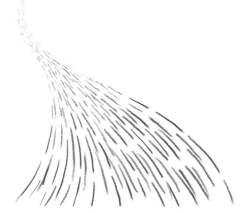

Short vertical lines drawn lightly and higher on the page can appear distant in comparison with the longer, darker lines drawn lower on the page.

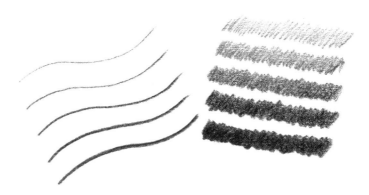

Just varying the pressure of the same pencil creates a wide range of tones.

58 Follow Cross-Contours

Contour lines define the outside profile (edges) of a subject. Cross-contours describe the inside of an object. They follow the direction and shape and create a textured map of the surface. Cross-contour lines may be horizontal, vertical, or both, but they always describe the three-dimensionality of an object's surface.

When you are drawing a three-dimensional object, the strokes should follow the cross-contours. This is especially helpful when you start shading. If you add tone along the cross-contours, the shadows will be more believable.

Quick Tip

Cross-contour lines get closer together the farther away they are, and farther apart the closer they are.

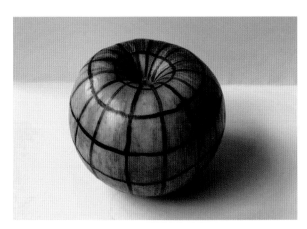

You can take an apple or other fruit and actually draw lines on it to better understand cross-contours!

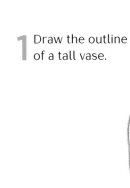

1 Draw the outline of a tall vase.

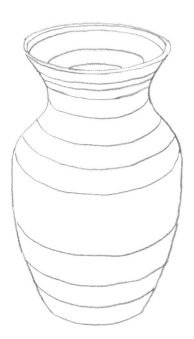

2 Add horizontal lines that follow the curve of the vase.

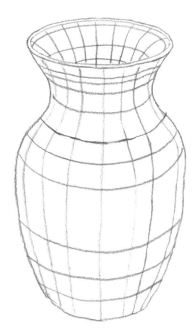

3 Draw vertical lines that follow the curves of the vase.

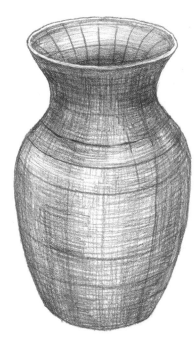

4 Use the cross-contours as a guide to shading the vase.

59 Keep It Light...Until It's Right

One of the secrets of making good art and avoiding frustration is keeping your lines light in your initial sketch. As you decide where to place marks on a page, use very little pencil pressure so your lines are light, sometimes barely visible. If you then want to move or change a line, it's easy to erase. Those light initial lines are called construction lines. They are not always in the exact right place. Once you're satisfied with your construction lines, you can increase the pressure to refine your drawing and move on to adding darker values.

In these initial sketches, I kept the lines light at first while I got the angles and proportions right.

Quick Tip
You can erase your initial rough lines or leave them in as a record of your process.

60 Create Separation with Shading

Overlapping in art is the placement of one object in front of or over another to create the illusion of depth. The closer object (or part of the object) obscures part of the farther object. To make an object look like it has even more depth, use shading to make sure that the objects or parts appear separate from one another. Notice each object's value relative to one another. Is the object/part in front lighter than the one behind it? Make sure the two parts to be shaded are different tones or hues. The objects closest to the viewer usually cast shadows on the farther ones, depending on lighting.

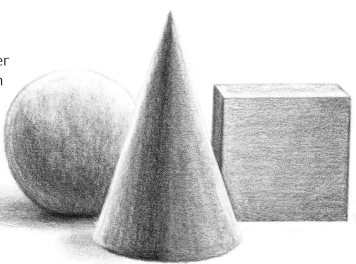

61 Convert Color Images to Black and White

Drawing in black and white instead of color has its advantages. You don't have worry about color theory and instead can focus on mark-making and tones. One trick you can use when drawing a subject from a digital image is to convert it to grayscale, or black and white. The black-and-white image reveals a subject's natural beauty, while making the contrast between lights and darks more evident. By removing the color elements, you can focus on the highlights and shadows of the subject to build its three-dimensionality. This simple trick helps identify and replicate all the values more quickly and enables you to draw more realistically.

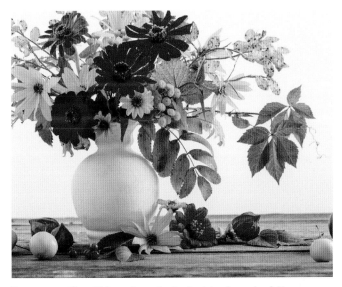 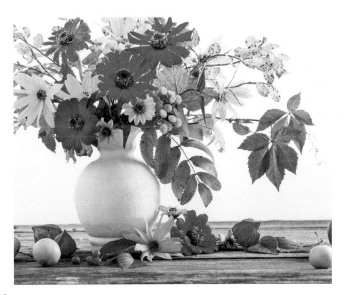

By converting this color photo to black and white, you can focus on the composition and values of the flowers when drawing them without being distracted by color.

62 Draw Realistic Fur and Hair

Drawing fur and hair so that they look realistic is about creating the illusion of texture. This is done by manipulating values and drawing in the direction of hair growth. Look at both the contour of the object as well as the inside (cross-contours) of the object.

Soft Fur

For soft fur or hair, draw the hair in clumps rather than individual hairs. It should appear smooth and bundled, not separate or sticking out. Blend pencil strokes together so some individual hairs are less distinct in softer sections of fur.

Changing Direction

The direction of pencil strokes changes as parts of the body bend and fold. The tone changes as well. A band of light is usually created anytime there is a curved area. Lifting tone with a kneaded eraser will make a band of light more visible.

Quick Tip

Remember that highlights are always seen on rounded or protruding areas.

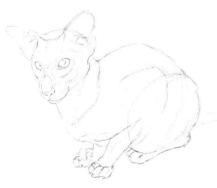

1 Draw the basic subject, paying attention to where directions change and light and shadow fall. These are good indicators of change in texture.

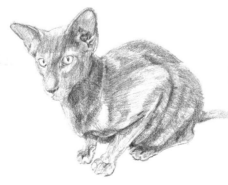

2 With a back-and-forth motion, and following the direction of the fur, fill in the overall tones.

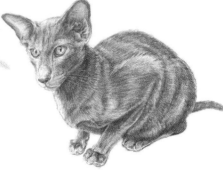

3 Add more tone for contrast. Build up the strands by layering them on top of one another using short hatch marks. Replicate the hair's direction and length with your pencil marks. Blend tones and lift out areas for highlights.

63 "Draw" with a Toothpick

It is nearly impossible to get a line as fine as a hair with a kneaded eraser. Instead, you can use a toothpick!

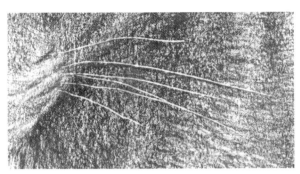

**I "drew" these whiskers with a toothpick.
Any thin, blunt tool will do the trick.**

Quick Tip
Too much pressure can damage the paper, so do some practice marks first on the same type of paper that is not your drawing.

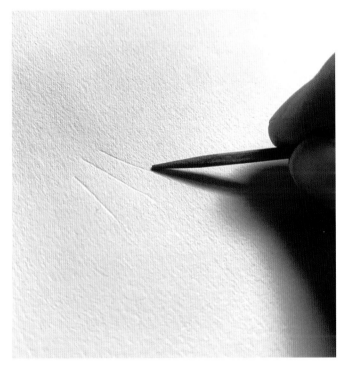

1 Using pressure, make dents in your drawing paper by dragging the toothpick across the areas you want to remain white.

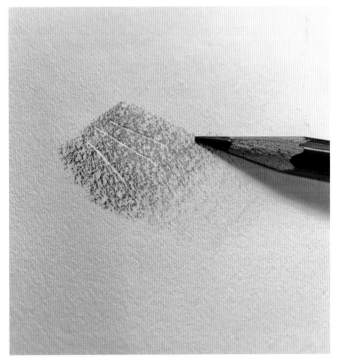

2 Hold a pencil at an angle and fill in tone over the dents with the side of the graphite with a back-and-forth motion.

64 Convey Motion

Drawings and paintings allow an artist to capture a scene during a moment in time. The scene stands still, as it is simply an instant that is recorded. At the same time, it is possible to expand that moment with motion. From the crash of a wave on the surf to a running figure, there are some tricks you can use to imply motion, action, and energy. Abstract work might show turbulence or unrest via colors, placement, and choice of line/shape. More realistic works may contain gestures, diminishing sizes, distortion, or emerging forms.

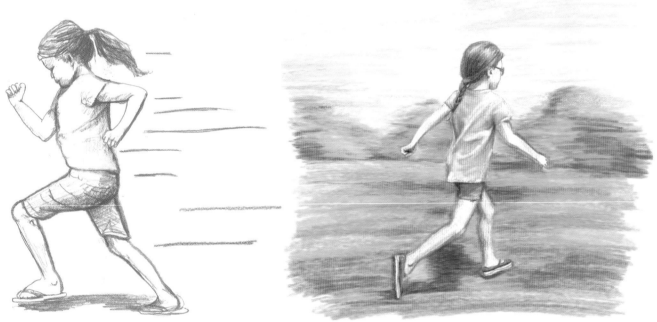

Drawing streaks to imply motion is effective but best for more cartoonish drawings.

Blurring the background is a more subtle and realistic technique.

Ways to Add Motion to Drawings

- Draw or paint lines behind the object that is supposed to be moving. This straightforward technique may appear cartoonish and not realistic but it may be the effect you want in your drawing.
- Use expressions on a subject's face to show the urgency with which they are moving.
- Draw an object about to hurtle off the edge of the paper, rather than in a relaxed position in the center.
- Capture the essence and movement of a figure with gesture drawing (see Secret #70).
- Blur the background while keeping the main subject in focus.

65 Shade Instead of Outline

Outlines make a drawing easier to see, but they don't always offer a realistic portrayal of the object, because most objects don't have lines around them. Instead of drawing contours for every object, you can use tonal changes to show form.

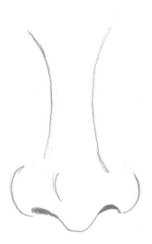

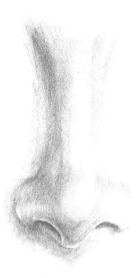

The nose drawn with an outline does not look realistic, because in real life a nose doesn't have an outline around it. It looks flattened.

Instead of a line, this nose is drawn with the edge of a pencil to indicate shade. It looks much more realistic.

66 Add a Cast Shadow

You may choose to draw a simple subject and omit a detailed background because you want the object to stand on its own. This technique can be very powerful; however, sometimes a floating subject doesn't appear as interesting as one that is somehow anchored to the background. A shadow or simple horizon line can help give the illusion of a subject secured to the surface. The result will feel more realistic.

The diffused shadow beneath the car (right) prevents it from hovering in midair and places it more firmly on the ground than the image with no shadow (left).

(67) Draw Convincing Glass

While drawing transparent objects such as glass may seem like a daunting task and technically difficult, it doesn't have to be hard. If glass can be seen, it can be drawn.

Even though most glass is clear, it still reflects some light and leaves highlights on its surface. The most important thing is to try to draw every highlight, shadow, and reflection as close to reality as you can. Draw what you see, not what you think you see. It might not make sense to your eyes at first, but the end result should be very realistic.

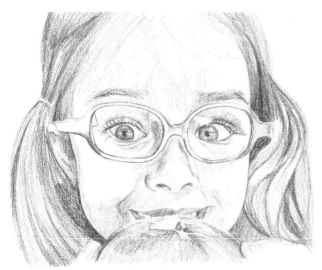

1 Draw the basic outline of the object, including the highlights and reflections. This step may leave you with a drawing that looks like a confusing bunch of lines, but it will come together in the end.

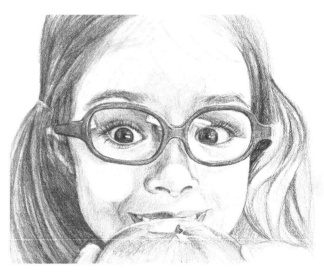

2 Begin to add shading and volume. Start by filling in the darkest areas of the image.

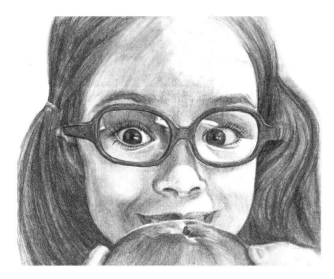

3 Add more tone to darken shadows and reinforce the pattern of highlights and shadows on the glass.

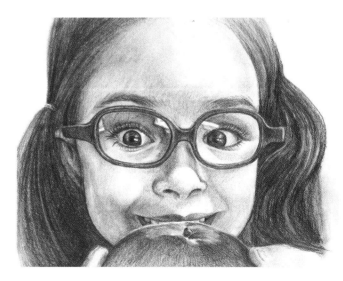

4 Darken tones and use a kneaded eraser to add or strengthen highlights.

68 Shrink It

Did you ever do shrink art when you were a kid? You would draw or color on a plastic sheet of polystyrene plastic, cut out the design with scissors, and then pop it into the oven to shrink it. Not only did the art reduce in size, but the "imperfect" scribble lines magically disappeared, and the colors and lines became more concentrated, giving the art a neater and more professional look.

This same theory can apply to an artwork. If you want to create a very fine, small drawing, it may make sense to draw large, and then shrink it down. By drawing large, you will have space for all of the details needed to add interest. By then reducing it in size, the particulars become finer and more intricate, resulting in a super-detailed image. This resizing feature can be found on any copier. You can also scan the image and manipulate it with photo-editing software. Use measurements and math or trial and error to determine what percentage to reduce the art. The main drawback to this method is that the resulting image will be a copy, not an original work.

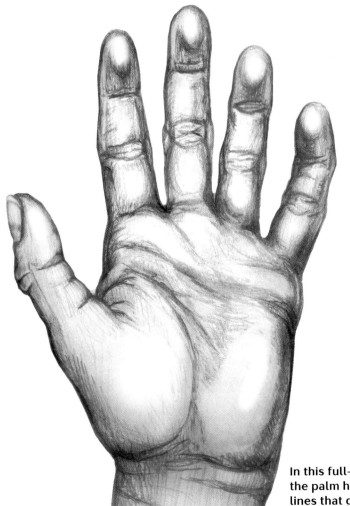

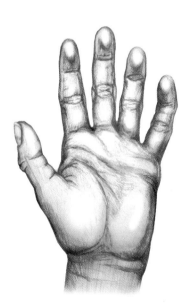

When the hand is reduced in size, the lines virtually disappear, while the focus of the art is placed elsewhere.

In this full-size image of a hand, the palm has many scribble lines that give it a certain stylistic appearance.

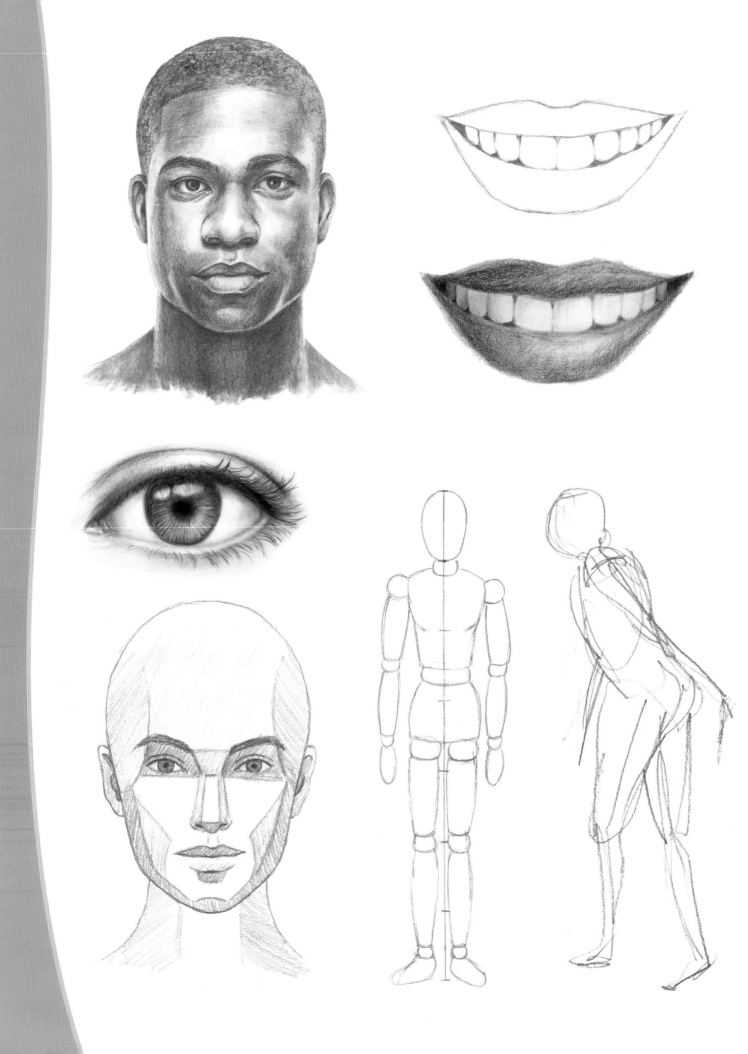

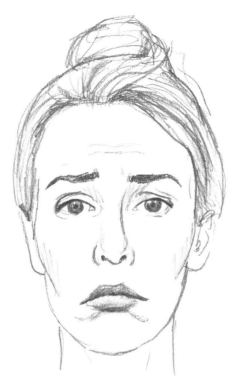
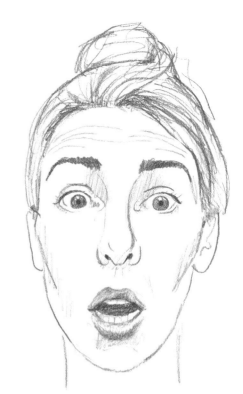

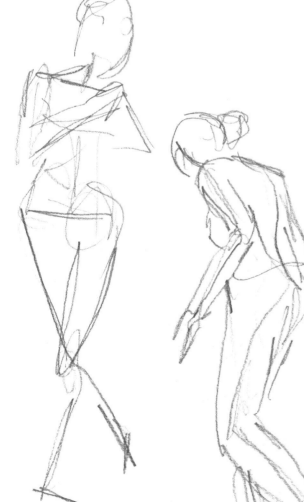

Draw People

The human face and figure are often considered the hardest subjects to draw. But they are also some of the most popular and rewarding. You can, and many people do, spend a lifetime studying the figure and learning to draw it, but there are a number of tricks you can use to immediately improve your drawings of faces and figures. It's not as hard as you might think!

(69) Count Your Heads

The human figure can be broken down into specific proportions. The generic adult measures up to be seven heads (or units) tall. This means the average adult is as tall as seven of their heads stacked on top of each other. This will differ from person to person, so this is just a generic guideline. In this demonstration, I'll use an artist manikin to keep it as simple as possible.

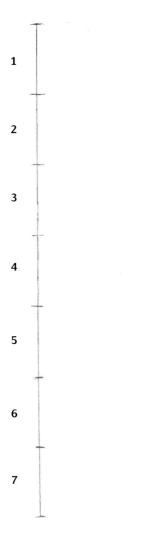

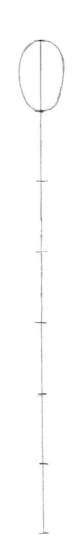

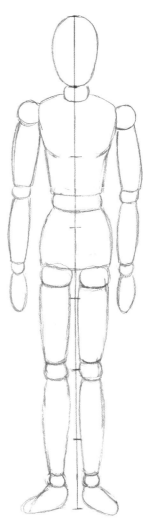

1 Draw a line the length of the manikin and divide it into seven equal sections.

2 Fill the top unit with an oval/head shape. The chin should be touching the bottom of the unit.

3 Use the marks that divide the body into seven sections as guidelines to fill in the torso and limbs. With these essential lines in place, you can finalize the drawing with the details that bring the figure to life.

70 Capture the Gesture

There is a lot going on inside the human body. Artists can take hours, days, or even years to complete one study of the human form. Gesture drawings are usually completed within 30 seconds to 5 minutes.

A gesture drawing is basically a quick drawing that captures the subject in its most condensed form and embodies action, movement, and expression into one connected sketch.

This exercise is great for warming up the fingers, hand, and arm for drawing and also improves observational and decision-making skills.

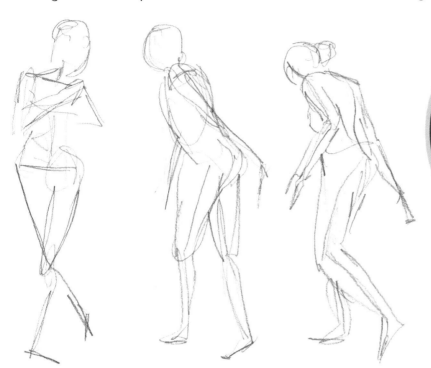

Quick Tip

A gesture drawing's subject matter is usually the male or female form since it is a great way to understand human anatomy, but animals or moving vehicles and machines make good subjects as well.

In these 30-second gestures, there is very little detail, yet there's a lot of information. The bodies are lively, showing motion and creating shapes as they contort and bend on the page.

Pointers for Gesture Drawing

- Sketch the main lines of your subject that indicate which way the body bends, any angles the hips or shoulders follow, leg direction, and arm direction.

- Looking at the major shapes and positioning of the subject, quickly block in areas with lines and curves.

- You should care more about how the gesture feels than how accurate it looks.

- Simplify as much as possible. There is no time to draw individual parts in any real detail.

- Your hand should remain moving at all times but should be relaxed yet efficient in its movements.

- If you make a mistake, just make another line to correct it. Don't stop to erase!

- Draw lightly to begin. If time allows, you can always go over your light lines and make them more permanent.

- Feel free to use any drawing tool to create gesture drawings. Try different ones.

- Use lots of curves. You are not drawing a stick figure and humans are not made of straight lines.

- Remember that the final outcome is not meant to be a finished drawing. It's just a practice exercise!

71 Place the Features Correctly

The placement of the eyes, nose, mouth, and other features is almost the same for everyone. Slight changes in shape and size of each feature make us look unique, but it's helpful to understand how to draw a basic face.

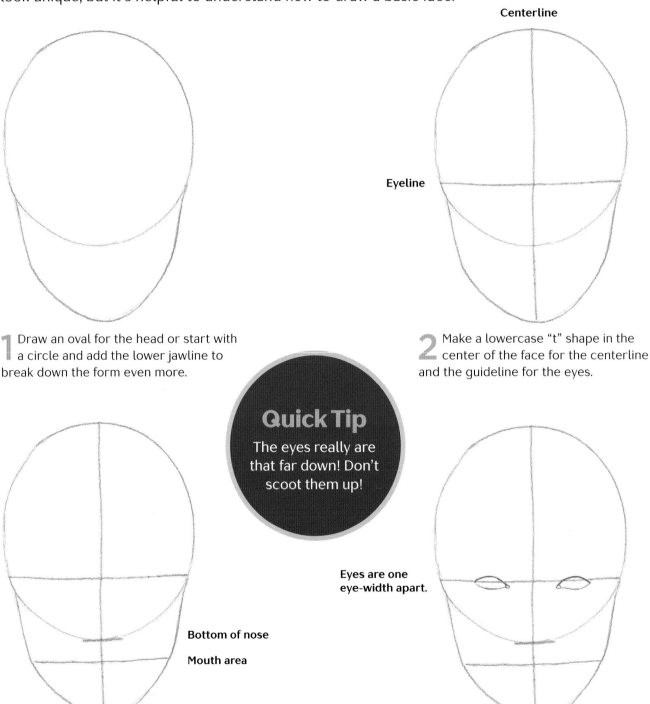

Centerline

Eyeline

Bottom of nose

Mouth area

Eyes are one eye-width apart.

Quick Tip
The eyes really are that far down! Don't scoot them up!

1 Draw an oval for the head or start with a circle and add the lower jawline to break down the form even more.

2 Make a lowercase "t" shape in the center of the face for the centerline and the guideline for the eyes.

3 Find the center point between the area where the "t" crosses and the bottom chin. Make a line there. This will be the nose bottom. The mouth falls roughly between the nose bottom and chin.

4 On the eyeline, draw two rounded football shapes. The space between your eyes is exactly the length of one eye, and the head is five eyes wide.

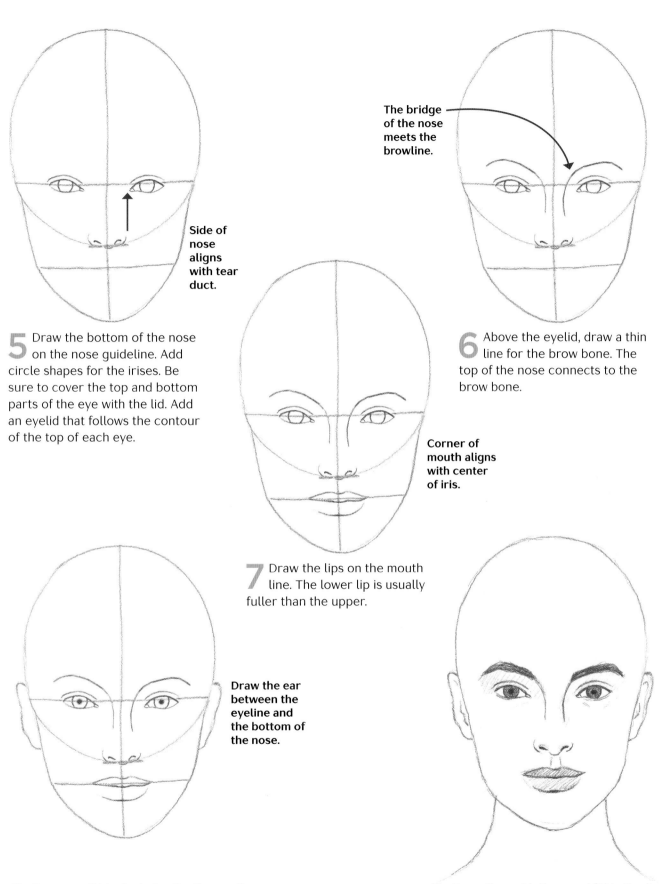

The bridge of the nose meets the browline.

Side of nose aligns with tear duct.

5 Draw the bottom of the nose on the nose guideline. Add circle shapes for the irises. Be sure to cover the top and bottom parts of the eye with the lid. Add an eyelid that follows the contour of the top of each eye.

6 Above the eyelid, draw a thin line for the brow bone. The top of the nose connects to the brow bone.

Corner of mouth aligns with center of iris.

7 Draw the lips on the mouth line. The lower lip is usually fuller than the upper.

Draw the ear between the eyeline and the bottom of the nose.

8 Draw small black circles for the pupils. For the ears, draw a curved shape that is close to the head.

9 Erase the guidelines and fill in the lips and irises with light tone. Thicken the eyebrows.

72 Use the Right Face Proportions

While every face is different, the placement of features is fairly uniform in any given age group. The eyes, nose, and mouth change as the face grows and ages. A baby's face looks very different from an adult's because of the size and placement of the features. Using a generic map of where to place facial features can help draw any age subject.

Baby

The baby's head is a U shape attached to a round ball. The bone structure is not yet completely developed, so the jawbone, cheekbones, and the bridge of the nose are relatively smaller. This makes the baby's face smaller in proportion to its skull, so that the face, from the brows down, only occupies about half of the whole area of the head. Distances between the nose, lips, and chin are shorter, making the features appear larger. The ears measure from the eyes to the mouth.

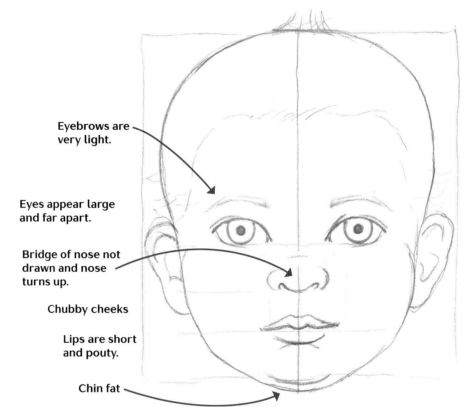

Eyebrows are very light.

Eyes appear large and far apart.

Bridge of nose not drawn and nose turns up.

Chubby cheeks

Lips are short and pouty.

Chin fat

As a child matures from a baby to an adult, the overall length of their head continues to grow.

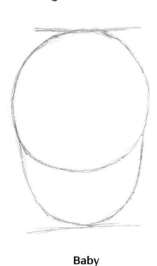

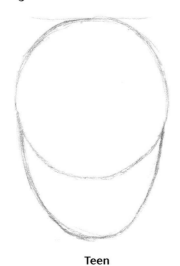

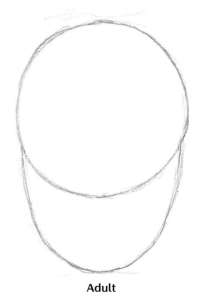

Baby
Teen
Adult

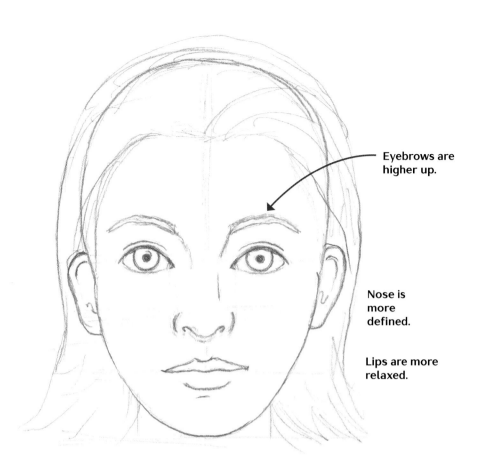

Eyebrows are higher up.

Nose is more defined.

Lips are more relaxed.

Teen

On a young teen, the head shape is larger and the U shape is longer and leaner. The eyes now take up less space while more of an eyelid appears. The lip shape changes from the baby lips, as they are relaxed and not as pushed together. The upper lip is still thinner than the lower lip. The chin is now part of the jaw, not a separate curved shape. The ears now appear smaller relative to the head.

Adult

The adult face shows proportions changing with age, but the differences can be subtle. The eyes have more lines to define them, including lines at the corners of the eyes. The ears are located in the same spot as on a teen but slightly bigger. The hairline is slightly higher, and the chin is defined more, with the shape of the jaw more delineated.

Eyes appear smaller.

Bridge of nose more defined.

Wider lips

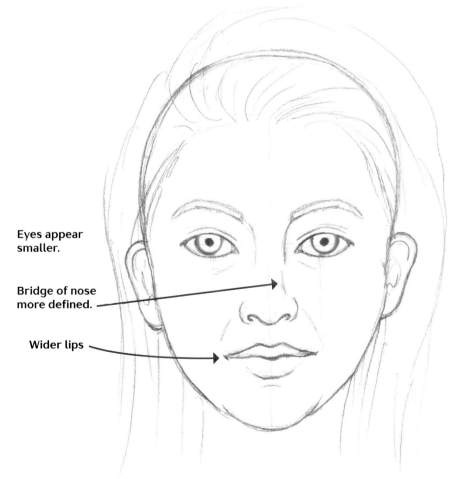

73 Use the Planes of the Face

The human head is a three-dimensional object but is often rendered to look like a flat surface. If you look closely at a face, you will notice that individual areas protrude outward or recede inward. These areas are called planes. Planes happen when forms turn and help to create dimension. Learning the planes of the face and noting where areas of the head go in and out will help you create realistic shading and aid in drawing the features.

Depending on the light source, these planes will be shaded accordingly. This sample shows a light source coming from above, which makes the planes that recede inward appear darkest.

Nose
The nose has four major planes: the center front, the sides of the nose, and the bottom. The bottom of the nose is almost always in shadow.

Lips
The upper lip is a downward-facing plane (receding inward) while the bottom lip is actually an upward-facing plane (protruding outward). The upper lip usually appears darker than the lower.

Eyes
The brow bone extends past the eyes, causing a shadow to appear on this downward-facing plane. This area has been simplified and made all one tone of a dark value, but the eyes protrude a bit, so some light will hit them.

Sides of the Head
The face drastically changes direction at the sides of the skull. These planes have been established with curves on the sides of the head.

Jaw
The area under the cheek and jawline connects the side of the head with the front plane, shown as a receding plane.

Quick Tip
Facial features that belong to the same plane should be shaded with the same values.

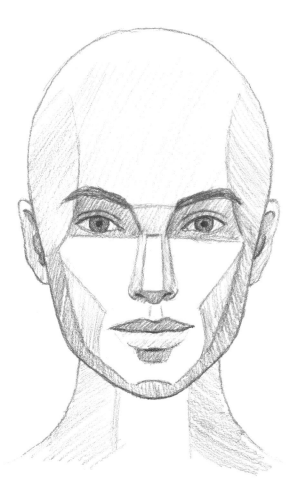

This is a very simplified guide to the planes of the face indicating the general location of the main planes. The planes can easily become more complicated, as every curve and turn of the face can be broken down into much more than what is shown here.

74 Avoid Perfect Symmetry

Symmetry is a fundamental part of geometry, nature, and shapes. Simply put, it means an artwork is the same on both sides. Whether we are conscious of it or not, our brains seek out symmetry, as it is aesthetically pleasing to us.

However, perfect symmetry in nature is very rare. Almost every natural object has some degree of asymmetry. This is where both sides are not the same. Some cases of asymmetry are more noticeable than others, such as in the case of fiddler crabs, animals with antlers, or flounder. But faces are not perfectly symmetrical either.

So as an artist, don't stress over trying to get both sides of an object perfect. Little "imperfections" in an artwork are what make the piece unique and interesting. And in the case of portraits . . . more realistic.

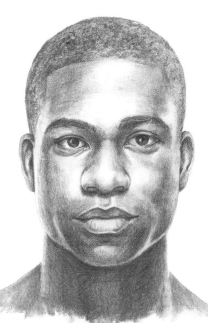

EXAMPLE OF A HUMAN FACE
The features are very similar from one side of the face to the other, but they are not identical.

LEFT SIDE OF FACE MIRRORED
In this example, the left side is mirrored on the right, and the portrait doesn't look quite right.

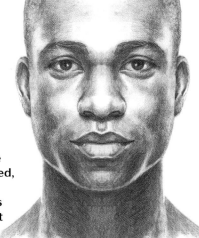

RIGHT SIDE OF FACE MIRRORED
Again, when the right side of the face is mirror imaged, the result is somewhat odd, and the subject looks like a completely different individual.

One of the many challenging aspects of drawing human faces is that it's not really just one expression you need to grasp, but many. This is because faces showing different emotions look very different from one another.

Whatever the emotion, an array of muscle movements is involved. The cheeks, brow, eye shape, nostrils, and mouth will all move in some manner. Just by looking at the eyes, one can decipher whether a person is smiling, upset, angry, and so on.

Quick Tip
Practice drawing expressions by looking at your own face in a mirror and drawing it.

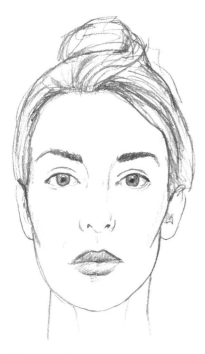

Neutral
There are no discernible facial muscle contractions and the face is relaxed. Use this expression to compare the actions and movements of other expressions.

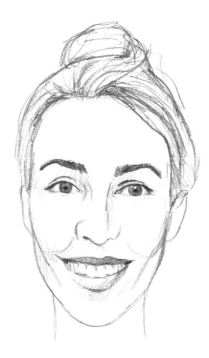

Happy
The corners of the mouth lift up, and the lines to the sides of the mouth deepen. The apples of the cheeks become fuller and higher, and the eyes narrow. The chin is brought down and is more pronounced.

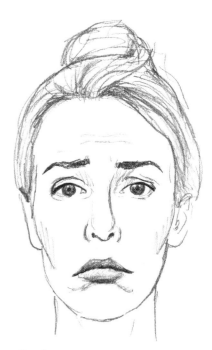

Sad
The corners of the mouth turn downward. The lower lip protrudes, and a shadow appears below it. The eyelids and eyebrows are raised and drawn together toward the center of the face.

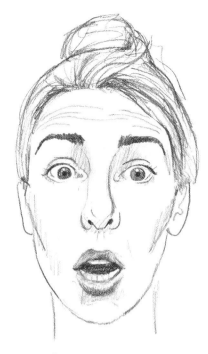

Surprised

The jaw drops, opening the mouth and relaxing the lips. The face lengthens. The upper eyelids curve upward and stretch so that the white part of the eye is visible above the iris. The eyebrows arch upward, wrinkling the forehead.

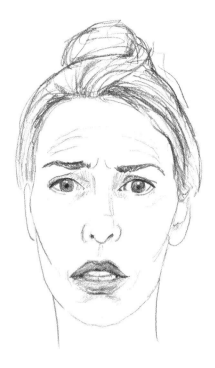

Afraid

The lips part slightly, and the lower lip protrudes. The eyebrows draw together and become more horizontal. The lids rise toward the center of the face and move downward toward the outside. Lines appear across the forehead and between the brows.

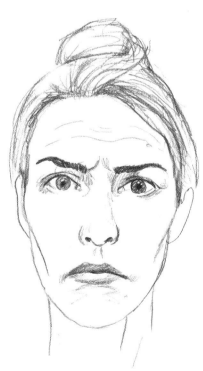

Mad

The mouth tightens and tenses, making the lips thinner. The eyebrows are pulled down and drawn together toward the center of the face. The nostrils flare, and deep lines appear on the forehead. Tension lines appear on the neck.

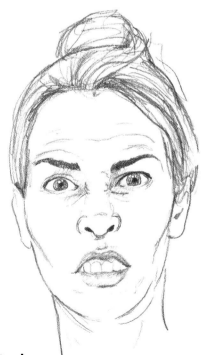

Disgusted

The upper lip is pulled up with teeth bared. The chin flattens and pulls in toward the neck, creating folds of skin. The nostrils rise up and outward, and the nose wrinkles. The eyes narrow as the brows arch downward and the forehead creases.

76 Make Your Eyes Stand Out

The eyes are usually the most prominent facial feature. Follow these tips to make yours the center of attention.

- Color the pupil black and the iris lighter.
- Draw "spokes" radiating from the pupil for detail.
- Leave a white highlight somewhere in the iris.
- Make the upper part of the eye (lash line) darker than the lower.
- Draw the lashes shorter as they grow toward the center of the face.
- Make the pupils and the eyebrows the darkest areas on the face. There are exceptions, but this applies for most faces.

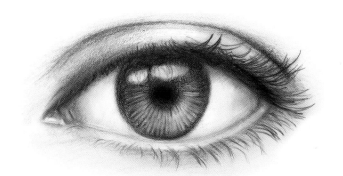

77 Draw Natural-Looking Eyebrows

Every eyebrow is different, but they all share similar traits. Follow these tips to make eyebrows look natural and blended with the face.

- Start the brow on top of the brow bone with few hairs. The direction of these hairs may fan out or even grow straight up before changing direction.
- Keep strokes thin. Parts of the brow may knit together and appear blended, but there are a lot of areas where individual hairs stand out.
- Draw the eyebrows thinner toward the ears. Hairs near the center become darker and more overlapped.
- Observe. Eyebrow hair strokes are not a predictable pattern. They can grow up, down, and from the sides.
- Remember that the length of a brow is slightly longer than the eye.
- Do not outline the eyebrow, as it will become difficult to erase and look unnatural.
- Notice that some hairs are joined together on the ends.

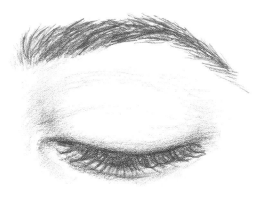

Below are three examples of eyebrows that do not look natural.

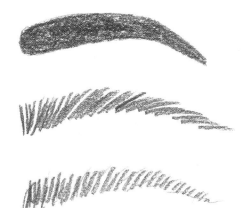

78 Draw Realistic Teeth

Human teeth are an important part of any portrait that displays a smile, but they can be intimidating to draw realistically. Shapes, sizes, and angles of teeth can vary greatly from person to person or even tooth to tooth, so it is important to observe what is being drawn.

1 Start with a basic outline sketch of the mouth, leaving a half-moon shape in the middle.

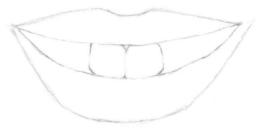

2 Next, draw the two center teeth, taking care to include the gumline curve above each tooth. On some people, the gumline is covered, while on others, it is clearly visible.

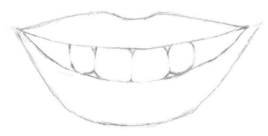

3 Draw the teeth on either side of the front teeth, noticing the size difference and placement. Avoid drawing them as mirror images. Also notice how faint the lines are to separate the teeth.

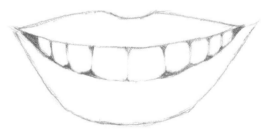

4 Draw the rest of the teeth. Find the areas that have the darkest shadows, usually between the teeth near the top and bottom, and fill them in with tone.

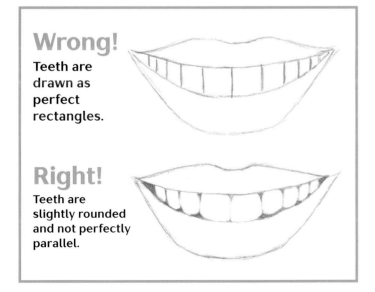

Wrong!
Teeth are drawn as perfect rectangles.

Right!
Teeth are slightly rounded and not perfectly parallel.

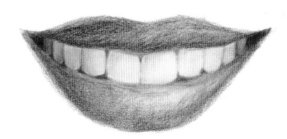

5 If you color the teeth, notice the hints of yellow near the center teeth where more of the teeth are hit by light and the cooler blues and purples close to the corners of the mouth in shadow.

Be Confident!

While most of the secrets in this book focus on improving your drawing skills, this section delves more into the mental side of drawing and art. Drawing takes practice and time, so if you want to get and *stay* motivated, you need to have the right mind-set. I'll share what I've learned about dealing with criticism, developing a signature style, forgiving—and using—your mistakes, and finding inspiration.

79 Be Yourself

Artists create art for many reasons. Some works have political messages, some are made to begin a healing process, while others are for pure creative expression, to name just a few. All of these pieces usually have one thing in common: They are being made for the artists themselves. When an artist seeks to create art for themselves, their art actually finds a way to reach people who are going to resonate with it. No one knows your artwork better than you. You have all the answers and none of them can be wrong.

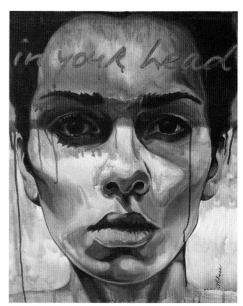

An accidental drip on my canvas became part of my style for a time. Not everyone liked it, but I did.

Tips for Being Yourself in Your Art

- Use references for inspiration, not imitation.
- Remember that everyone can draw, but no one can draw just like you. You have something to offer no one else in the world can. Show it.
- Don't worry about what others think. You can't please everyone, so don't try to.
- Listen to comments and criticisms, but you don't need to become a reflection of other people's opinions or directions.
- When you explore what makes you happy and who you are in the world of creativity, everything will fall into place.

80 Draw on Your Own Experiences

Everything you experience in life becomes a part of who you are and part of your art. This may be expressed through color, medium, perspective, or subject matter, to name just a few. When you put something personal into your work, that's when it resonates with people the most.

To fully use your background to your advantage, dip into your experiences and use what is unique to you to add authenticity and interest to your work. It could be a memory or feeling you have experienced that you want to explain. It could be a scent or a sound that you experienced while creating your art. The product can be abstract or realistic; all that matters is what you put into it that makes it unique.

As art is said to imitate life, our experiences add significance to every mark we make.

I created this collage using pages from the real estate section of the newspaper when I was searching for a home.

81 Ignore the Haters

There is plenty of angst involved in making art: the fear of not being able to capture the image we have imagined, the dreaded artist's block, and, perhaps worst of all, critics. These can all get in the way of confident art making. No matter what you do, there will always be someone who will not like your work. Fortunately, you do not require a unanimous vote of approval in order to create. All art isn't for all people. It is subjective and based on personal judgments and emotions, not facts. The process of viewing art, just like creating it, is entirely a personal and individual process. What you think of your art is what matters. If you are happy while you are making it and happy with the end result, that is a good reason to make art. There will always be haters. Don't let them get you down!

82 Take a Break

An artist can work on a piece of art for long periods of time—sometimes too long. Breaks, no matter how long, can help avoid burnout, offer a chance to recharge, and allow new ideas to brew within you.

Social media and instant access to information at every moment of the day can cause a relentless, omnipresent pressure to always be available or "on." You might even put pressure on yourself to produce.

Too much time working on a piece can cause you to become blind to your own mistakes. Taking a break helps your brain rest. When you come back, all the flaws become more apparent and solutions become possible. You can't fix a problem if you don't see the problem.

It's also important to spend time gaining inspiration from life. If you spend all of your time practicing, you may not be fueling your creative brain enough.

Don't worry that you'll stop improving or growing as an artist if you pause your work. Your brain will actually relax and be eager to start creating again. Remember, art should be enjoyable and relaxing. If you find that it is becoming a stressor, take a break!

Quick Tip

When you do take a break, make sure you don't throw out the piece you've been struggling with. You won't learn anything from that, and you won't have an artwork to refine when your break is over.

83 Develop a Signature Style

Something that an artist does to set them apart from other artists is a signature style. It may be the materials used, a distinctive set of colors, or a specific topic, such as cats or landscapes. An artist with a signature style is instantly recognizable.

Pop/modern artist Roy Lichtenstein had a very specific style that is instantly recognizable: The use of primary colors, thick outlines, and Benday dots make his work appear machine-made. Ansel Adams's bold, black-and-white landscapes of the American West are also instantly recognizable.

Why have a signature style? Not only will it make a first and lasting impact on a viewer, but it will also help define your brand. Branding makes a memorable impression and shows viewers what to expect from your art.

How do you discover your signature style? First, look at what you enjoy creating. What subject do you spend most of your art time on? What are you good at? If you have sold work, what sells the best, easiest, and the most? Most importantly, when you lose track of time, what kind of work are you making? This is the stuff that you are passionate about and will truly enjoy creating.

Using certain colors, techniques, and subject matter are a few ways of exploring a signature style. This image uses one of my favorite techniques: wet-in-wet watercolor.

Quick Tip

Once you have a signature style, make sure there is enough variety in your work. If portraits of Abraham Lincoln are your signature style (someone in Gettysburg is making a great living at this), ensure that you can easily paint thousands of different variations of Abe.

84 Forget Perfection

I have had many older students fall victim to the fear of failure. With just one small mistake or misplaced line, the paper would be thrown away, and the student would refuse to continue for the rest of class. This rarely happens with my elementary-age students. They are happy to just create. As much as human beings may strive for perfection, it is an unrealistic aspiration. People aren't perfect, and unless you're a neurologist performing brain surgery, you rarely need to be. In art, there is room for error; in fact, it is encouraged. "Mistakes" can lead to some creative problem-solving.

The misplaced drips in this watercolor started out as mistakes that have become a deliberate part of my signature style.

Tips to Avoid Perfectionism

- Set yourself up in an environment conducive to creating your best work.
- If you're feeling hesitant to get started, push yourself to begin anyway.
- Take breaks if needed but always keep going back to your work.
- Know that you don't have to create a masterpiece every time you pick up a pencil or paintbrush.
- Don't dwell on past failures. You can't move forward if you're always looking back.

- Know when to stop. If you always find yourself thinking there is one more thing you want to change, it might be time to step back and try something new.
- Celebrate your successes by taking a moment to be proud of one of your accomplishments, no matter how small.
- Don't compare yourself to others but rather to your own earlier works.
- It's okay to start over, but first try to fix your issues or work with them.

85 Focus on the Process, Not the Product

Process-focused projects are about play, experimentation, exploration, and discovery, rather than a perfect piece of art. Focusing on the process helps you think creatively and independently while researching the possibilities and physical limitations of materials. Experimentation and mistakes are a part of the process, and since you have no end result in mind, the experience should be calm and relaxing.

Process art can be made with almost any materials. Collage techniques, painting on unusual surfaces, using staples or tape to decorate with, scraping the surface after it has been painted, and taking several days using a variety of materials are a few of the thousands of ways to make process art.

In this example of process art, I focused on what I was doing in each step and experimented with the materials.

1 I ripped colored tissue paper into small pieces and placed them over a piece of cardstock until little or no white was showing.

2 Using a squirt bottle, I wet the tissue paper thoroughly. After letting it dry for a few hours, I removed the tissue paper to reveal the blended colors on the surface below.

3 With a black pen, I drew a portrait of a little girl over the blended colors.

4 I collaged flower cutouts onto the drawing and added paint to enhance the lips and eyes.

86 Get Inspired!

You finally carve out some time to sit and be artistically productive, surround yourself with your materials, and . . . nothing. Your mind is a blank, with zero inspiration. Unfortunately, creative impediments are not an unusual occurrence. Finding inspiration for your art is something you have to work at no matter how much experience you may have. Being motivated to create is not a constant state of mind, so giving yourself a push in the right direction might be all the incentive you need.

Ways to Find Inspiration

- Make a list. If an interesting idea occurs, write it down, even if you don't have time to execute it at that moment. Refer to the list when you get stuck or need an idea.

- Keep a sketchbook and pencil handy. Creating a rough sketch of what you are thinking in the moment can help you later visualize a concept for a future artwork.

- Take photos and put them in a folder on your computer to refer to later.

- Mix up your subject matter to expand your horizons and have a wider variety to choose from.

- Look at artists who inspire you. Decide what it is about the art that you like. Is it the style? Subject matter? Try to discover more about that artist's influences and follow those leads, while finding a voice of your own.

- Listen to inspiring music. Classical music can relax your thinking while creating a pathway to intuition and deep feeling. Rock or other high-energy music can bring forth energy, quick motions, or anger. The right music can open the doors to certain inspiration. (Silence can be inspiring as well.)

- Take a walk in nature and notice all of the fascinating shapes, hues, and sounds of your surroundings, and things that are easily missed.

- Think about a memory from childhood or another time in your life and create an artwork inspired by it.

87 Practice, Practice, Practice

Practice makes perfect. It is an old adage we have heard many a time, and for good reason: The more you do something, the better you get at it. By practicing drawing, you can better understand your subject matter. That understanding could be the simple shapes used to make up more complex forms, the detailed anatomy of a subject, the gentle curve of a line, or the subtle change of tone. The more you draw something, the more you will remember and know it. Practice can also aid in finding the best pencil grip, harnessing the power of observation, and exercising creativity.

For significant improvements, you should spend more time practicing, but spending any amount of time at all is a great start! The more you draw, the better you will get.

Tips for Getting the Most Out of Your Practice

- Draw the same image over and over.
- Draw from direct observation.
- Use art books or video tutorials.
- Try drawing the same subject with a variety of mediums.
- Experiment with techniques.
- Focus on areas you struggle with.

88 Set a Time Limit

Many people would love to learn to draw but feel they don't have the time to take a class or hone a new craft. On the other hand, some practicing artists may find they're spending too much time on an artwork or specific parts of a work. In either case, it can be helpful to restrict the time you're spending on an artwork. Setting a time limit can allow you to focus on the subject more quickly and include only important features that are really needed. The end result may be looser or less polished, but that can be a good thing. Limiting the amount of time spent on a drawing or on your daily drawing practice can make it seem less overwhelming as well.

89 Be Patient

Being an artist tests one's patience in so many ways. Whether it's learning a new skill or struggling with getting our art just right, patience is a necessary skill to acquire. The ability to remain calm, even when dealing with something painstakingly slow, enables us to develop, grow, and mature in our work as an artist. Lack of patience can cause frustrations, stop us from doing our work, and possibly ruin our art if a hasty decision is made. Through concentration and strength of mind, patience stops us from the temptation to end our work but can also give us the knowledge of when to step away.

Ways to Practice Patience

- Work at your own pace. Everyone has an internal motor that drives or inspires us in different ways. Don't let time (or other people) rush you.
- Accept that what you make won't be perfect. Enjoy the process of creating and learning from the results.
- Take a break. Step away when a piece becomes too overwhelming and take some time to reflect on it.
- Celebrate the small victories. Savoring even the smallest achievements will inspire you to keep on working and endure.

I created the fur and hair with a series of lines that varied in weight, pressure, and pencil choice. Finding the right combination of lights and darks along with direction and thickness was time-consuming but not difficult.

90 Take Risks

Taking risks is scary. What if you can't do what you set out to do? What if you end up "wasting" a lot of expensive materials? Why actively pursue something that could eventually fail miserably? All of these questions can stop you from taking risks.

Risk comes with the territory of being an artist. The sooner you become comfortable with taking risks, the faster you'll be able to advance in your skill and abilities.

Encourage yourself to push beyond what you consider to be "safe." It can be liberating to start a work even if you don't know what the outcome is going to be. With great risk comes great reward. Get outside your comfort zone—that's how you learn.

Challenges for Taking Risks

- Find a new artist that you like, and try to incorporate an aspect of their style.
- Try a medium you haven't tried before.
- Venture into a new subject matter. If you always draw dogs, try drawing other animals.
- Draw upside down (see Secret #24).
- Use your materials in a new way. Tape a piece of charcoal to the end of a stick to force yourself to work from a distance.
- Draw from an unusual angle or point of view.
- Try a different style. Instead of smooth, blended strokes, try chunky, blocky ones.

After painting this skeleton, I decided to add a three-dimensional effect by gluing metal carpentry nuts to the spine. I could have ruined a perfectly good painting, but I like the effect!

91 Leave Parts Unfinished

When working on a drawing, you've probably asked yourself, "Is it finished?" There are different times you may leave a work "unfinished." Sometimes you get frustrated or tired of it and abandon it. Then there are those works that have been deliberately left undeveloped. An Italian term, *non finito,* was given to this style of work, which describes the intentional "un-finishing" of a drawing or painting. There is a lure of secrecy and an enticing sense of mystery to *non finito* works. The lack of information also forces the viewer to investigate a work further as their imagination fills in the blanks. You must decide between which parts of a work should be present and which parts to omit altogether.

Leaving some areas incomplete highlights areas of the drawing I want to draw attention to.

92 Consider Opposites

It is said that people who are very different from each other are often attracted to one another. But is it true with art? Can unrelated styles, mediums, and subjects work well together?

The works that hold attention are the ones that make a viewer curious. The disparities within opposites that seem so puzzling may actually be the very things that make a work so distinctive and interesting. Opposites can happily exist side by side, as they offer balance in an artwork.

Try brainstorming a list of words, and then list their opposites: night and day, rich and poor, sadness and joy, past and future. You can also play with opposites by choosing mediums and techniques that don't normally go together. Rough swipes of paint mixed with delicate line drawing or smooth paint strokes intertwined with chunky collage materials can be dynamic uses of opposites.

The yin-yang symbol is an excellent example of opposites, as it is a symbol of forces that are inseparable and contradictory but so interact to maintain harmony and balance in the universe. There cannot be one without the other.

CHAPTER 7

Get Creative

This chapter is all about having fun with your artwork! The way to grow in your art is to stretch yourself and experiment. I share some of my favorite creative techniques, such as distortion, two-handed drawing, playing with unusual textures, adding special effects, and using prompts to inspire you and encourage you to try new things. I hope you enjoy them as much as I do!

93 Use Prompts

Ideas are a huge part of art and even more important than the manner used to create a work. It should be ideas that drive an artist to learn techniques, not the other way around. One way to get thinking and engage your mind in a creative mode is to use an art prompt. An art prompt is basically a suggestion, starting point, question, or challenge to draw or paint something. They can help spark your imagination if you're feeling a creative slump, bringing back the passion for creating. They inspire creativity when faced with a blank piece of paper. They offer suggestions, yet are remarkably open-ended to help you "think outside the box" and promote critical thinking.

Quick Tip

There are many online challenges that provide drawing prompts. Participants draw something each day and post their work online to share.

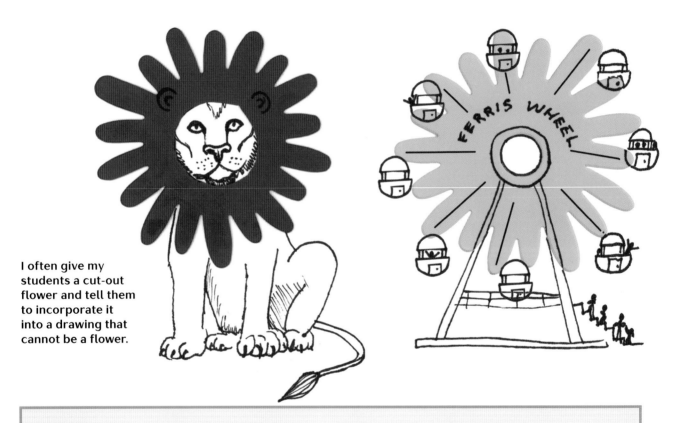

I often give my students a cut-out flower and tell them to incorporate it into a drawing that cannot be a flower.

Ideas for Art Prompts

- Ask friends for ideas. Andy Warhol did this and ended up with canvases full of soup cans.
- Look at art you love for inspiration.
- Take a creature and put it in an unusual situation. How about a surfing giraffe?
- Put an object or creature in a situation opposite of where it would normally be found, such as a fish looking into a bowl at a human swimming.
- Illustrate a scene from your favorite song.

- Draw an underground animal habitat that looks like a human home.
- Combine two subjects that don't belong together in the same scene.
- Try this scribble challenge drawing activity: You and a friend each scribble on a piece of paper, trade papers, and complete the drawings.
- Take an organic shape cut from paper and use it as an item in your drawing.

94 Draw with Both Hands

Double, or two-handed, drawing is a fun exercise that engages both sides of the brain simultaneously while testing the skills of your nondominant hand.

To begin, find two writing tools and hold one in each hand. Tape a piece of paper to a flat surface, as you won't have a free one to hold the paper steady. Don't waste your good art paper on this; a few pieces of printer paper will do.

Place the tips of each pen side by side anywhere on the page. Without lifting your markers, start moving the pens simultaneously in the opposite direction from one another. As the pen in your left hand moves to the left, the pen in your right hand should move toward the right, and vice versa. Whatever one side does, the other should do. You can draw freeform shapes or have a specific image in mind.

It might feel awkward at first, but stick with it. You might be pleasantly surprised with the outcome.

Quick Tip

Double drawing is a fun activity even kids can do with success.

Use two different colors to highlight the two sides and create a fun effect.

95 Go Abstract

Abstract art does not attempt to accurately represent a subject but rather uses shape, hue, and gestural marks to achieve an effect. It can be some of the most exciting and expressive artwork out there. Abstract art provides a distinctly different way for artists to convey their ideas, while challenging the viewer to see in unfamiliar ways and expand their imaginations.

Have fun! Although there are rules to making an abstract work, try not follow them too closely or the spontaneity and creativity of the work could be diminished.

Tips for Creating Abstract Art

- Concentrate on the placement, size, and shape of objects in the drawing. This will offer balance and interest.
- Find a realistic artwork you like and break it down into individual shapes and lines while ignoring the details.
- Try not to use every color of the rainbow in an abstract work. In fact, choose only a few colors to use.
- Three-dimensional perspective is not needed for a successful artwork. Color and visual sensation can be used to show that reality is subjective.
- Create in black and white, focusing more on shapes and composition rather than color to create movement and tell a story.
- Work large. It promotes a loose style and encourages bold marks.
- Play with texture. Texture can convey a variety of messages and emotions while giving an artwork a sense of object-ness.
- Use recognizable objects for the subject matter, but create them in a unique and unrealistic manner.
- Let music guide the strokes. Play anything from a classical tempo to a heavy metal tune, and let the music guide you as you create.

In this abstract painting I used complementary colors and texture to create a vibrant composition.

96 Distort

Distortion is a great tool to have in your artist's toolbox. Distortion involves changing the way something looks from its original appearance to become new, different, or surreal. It can be done by lengthening, shortening, bending, warping, squeezing, or twisting an object in some manner that deforms and exaggerates its features. You can also use unexpected colors, shapes, or lines to better express an emotion, feeling, or idea. Since artists don't have to record exactly what they see, distortion is a great way to transform reality into something more meaningful.

Caricature artists make visual parodies that highlight certain parts of a subject. Here, elongated fingers show elegance, thick eyelids and drooping features represent weariness.

97 Exaggerate Contrast

Contrast in art stresses the difference between two related elements, such as color, shape, value, and texture, and adds drama and interest. Hyper contrast is a trick you can use to make a part of your work really stand out.

One way to do this is to have lots of dark and light tones without many middle grays. This brings more focus to the white/lighter areas. Dark colors against light colors can create high contrast as well.

Another way to create high (hyper) contrast is to use contrasting colors. These are colors that are opposite one another on the color wheel. For instance, if purple and yellow (opposite colors) are used, the yellow will seem to jump out.

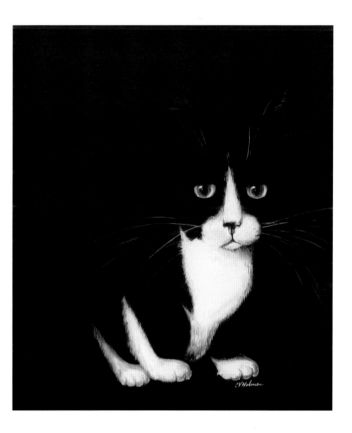

This image has almost no middle tones, making the cat's white fur and yellow eyes really pop.

98 Play with Real Textures

Texture is an element of art that focuses on the perceived surface quality of a work. Incorporating actual texture is a great way to add more interest to an otherwise flat area. Actual texture gives an artwork a sense of substance, associating it with the physical world. It can affect mood, awaken cognitive connections, and bring attention to a specific medium. Skillfully chosen textures can challenge a viewer's awareness of what is real.

Drawing these dice on cardboard, and then cutting and removing part of the top layer to reveal the corrugated texture beneath, enhances the three-dimensional effect.

Ways to Add Texture

There are so many ways to add texture to your art. Don't be afraid to experiment. Here are a few ideas:

- The impasto technique is thickly textured paint applied to a canvas that is almost three-dimensional in appearance, leaving visible brushstrokes on the surface.

- Dragging items through thickly layered paint such as specialized paint scrapers or even a simple household comb can further enhance the textures.

- Sand, dirt, or grit can offer an interesting texture to draw or paint on. Mix them with gesso to prime a surface, or purchase painting mediums with sand or silica added.

- Introducing collage techniques to a drawing is a quick and easy way to build up a surface.

- Stencils can leave a layer of texture to work with when laid on a surface and painted or drawn over with charcoal or oil pastels..

- Modeling paste is a thick substance that produces a textured effect when applied to a surface. Mix it with acrylic paint while still wet to create a thicker paint, or draw or paint over the top of dry paste.

- Crumple up your drawing paper, and then flatten it out before drawing on it. This creates an interesting texture that can tell a story depending on what is drawn on it.

99 Draw on Unusual Surfaces

Most artists grab a canvas or piece of paper as the go-to material to draw or paint on, but art can be made on just about any surface. In fact, artists in times past created on many surfaces not frequently used today, such as wood panels and cave walls. Using a nontraditional surface can really make your art stand out. Cheeming Boey is an artist best recognized for his intricate illustrations on white foam coffee cups with black pen. Anything goes! There aren't any rules when it comes to making art or the surface it is created on.

I painted these lovely ladies on the pages from an old book. The yellowing paper gives it the feeling of an antique photo.

Quick Tip

When choosing a nontraditional surface to draw on, consider factors such as accessibility, durability, longevity, and aesthetics.

Surfaces to Try

- Newspaper, shopping bags, or cardboard are cost-effective and readily available, and have absorbent surfaces.
- Glass or metal.
- Wood panels provide a sturdy base and sometimes have natural elements that bleed through and enhance the artwork.
- Human hands. Yours or someone else's.
- Three-dimensional items such as paper coffee cups can encourage you to consider multiple angles and points of views.
- Walls.
- Natural found objects such as bark or leaves.

100 Make Your Drawings Glow

Halation is a trick you can use to make objects appear to glow or vibrate. The dictionary defines halation as "a blurred effect around the edges of highlighted areas in a photographic image." In a drawing, halation adds interesting color variety, heightens contrast, and increases luminosity. The effect gives the drawing a somewhat cartoonish, but appealing, look that makes it pop off the page.

To create the halation effect, draw around the object with a complementary color (color on the opposite of the color wheel—see Secret #38). The halation color can be close to the opposite or the exact opposite.

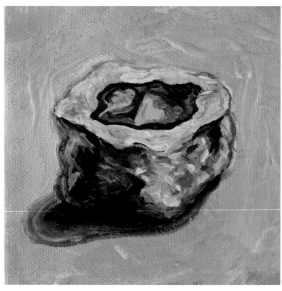

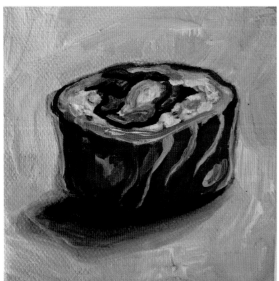

When you look at the sushi, you can see there is something not quite realistic about it. The blue shadow is intensely exaggerated, and there is a thin blue outline around its contour that adds interest to the work.

Quick Tip

To increase the halation effect, you can outline the contour of the object with two or three complementary colors.

1 Draw a simple outline of the cake slice using basic shapes.

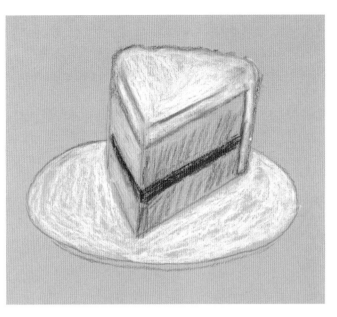

2 With oil pastel, block in the basic colors of the cake. Add bluish hues to the white frosting to indicate shadow.

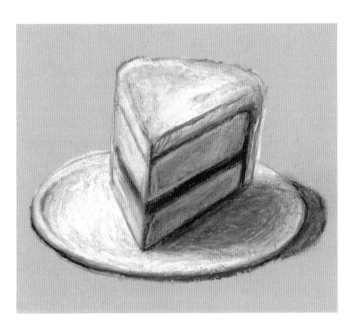

3 Blend the tones and add hue to indicate the light source and cast shadow.

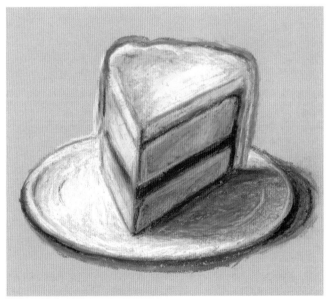

4 To add the halation effect, look at a color wheel and choose a color that is across from the blue of the frosting—in this case orange. With orange pastel, draw a line around the cake slice and the plate, closely following the contours.

101 Experiment with Different Materials

There are lots of unusual materials that can be used to make an artwork unique and are a lot of fun to experiment with as well. Different art mediums open up a host of possibilities.

When you use unconventional materials, you must experiment because there is no specific guide or map to describe how best to navigate their own practice or what other possibilities there may be for creating.

Using new materials can help you loosen up and leave some of the outcome to chance. It makes it more about process than product.

You might even want to use materials you have mastered in different ways, such as wetting a graphite drawing with alcohol and brushing it to create a painterly effect. Or try the same technique with different materials, such as painting with a stick dipped in paint.

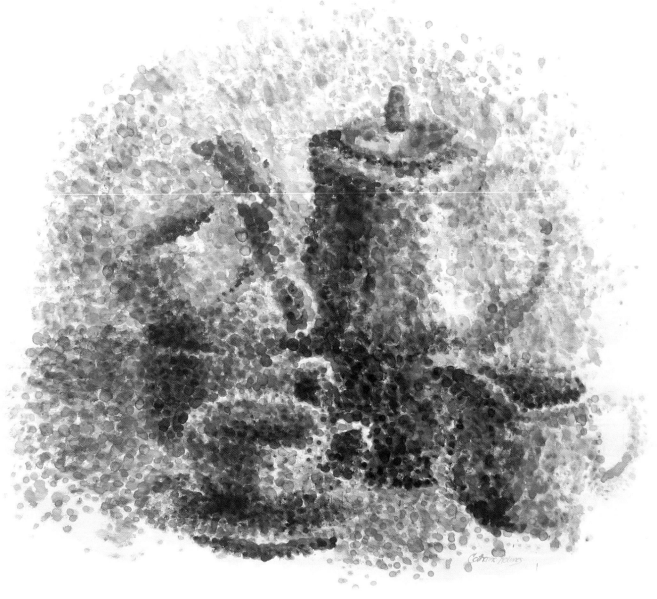

Here I dabbed my finger in ink and used it to "paint," which created an Impressionist-style still life.

Sprinkling salt on wet watercolor creates fascinating textures.

Unusual Mediums to Explore

Here are just a few of the thousands of ideas you could try using unusual materials or using common materials in an unconventional way:

- Create overlapping fingerprints with ink or paints.
- Dab bubble wrap in paint to print.
- "Draw" with string by gluing it to paper.
- Stitch a design on thick paper or cardstock with thread.
- Make a collage of various colored sticky notes.
- Sprinkle salt or sand onto wet paint. Salt may resist the paint and make an area lighter, while sand will create a texture and appear to darken areas.
- Draw on paper stained with coffee or tea.
- Brush over a charcoal drawing with water to deepen the tones and fix the charcoal.
- Draw using oil pastel or crayon, then paint over it with watercolor or an ink wash to create a resist effect.
- Collage an image by cutting out shapes from different colored or textured papers or old paintings and sticking them together.
- Paint on watercolor paper with clear water. Touch various paint colors to the wet areas and watch them spread.
- Apply thick acrylic with a palette knife to create an impasto effect.
- Use found objects from nature such as twigs or leaves as paintbrushes.
- Make a mosaic of colored cereal pieces, seeds, or pasta shapes.

Watercolor painted over oil pastel creates a resist that is a fun effect.

Final Note

Thank you for checking out this book! Whether you read through and tried all the secrets from 1 to 101, focused on a section you found interesting, or just bounced from tip to tip that caught your eye, I hope you picked up some helpful information, strategies, techniques, and inspiration to help you on your journey to improve your drawing skills.

Here are just a few more secrets I'd like to leave you with as you continue to read and use this book:

Suspend Judgment

Some of the tips might not have made sense when you first read them. Try them out anyway! You might discover a new and creative way to draw something.

Have Fun

This might be the most important pointer of all. Drawing should be fun. Don't take yourself too seriously and be open to making mistakes. If you're like most people, you are drawing as a hobby, but even if you're a professional artist, you should still strive to enjoy yourself.

Keep Learning

The secrets in this book are meant to be quick and are therefore brief. If you find a certain topic interesting, feel free to do some research online or in other books to learn more about it. There's always more to discover.

Stick with It!

In the introduction to this book, I talked about how drawing is not a mysterious talent that only a lucky few possess. It is a learned skill that is developed only through practice. However you choose to use this book, the most important thing is to actually try out the secrets and practice, practice, practice. If you find something difficult, take a break or try something else, but keep trying!

—*Catherine*

Index